What people ar

This book is a "must-read" for anyone who enjoys preserving stories! With plenty of inspiration and resources to help you get started, Mollie outlines all the basics you need to know when making your own photo books! I highly recommend it! ~ Caroline Guntur, The Swedish Organizer

"What fun to read! There are so many photo book examples, I was inspired to start creating a photo book about my dog's escapades and then a recipe book with photos of my cooking. My mind is turning on what I'll do next. My family and friends will love seeing the books when they are done." ~ Jeanie

If you need photo book help, this book has a lot to offer. With simple language and clear steps, I found it easy to follow the system to make a photo book. There are many options and examples to explore and this guide has so much in one place. Plus, I grew up in the late 80s and early 90s and could identify with the author's reminiscing of the way printing used to work. ~ Mary

Other books by Mollie Bartelt:

A Simple Guide to Saving Your Family Photos
A Simple Guide to Tackling Your Digital Photo Mess

Published by HenschelHAUS:
The Pixologist's Guide to Organizing
and Saving Your Family Photos

THE PIXOLOGIST'S GUIDE TO CREATING A MEMORABLE PHOTO BOOK

THE PIXOLOGIST'S GUIDE TO CREATING A MEMORABLE PHOTO BOOK

MOLLIE BARTELT

HENSCHELHAUS PUBLISHING, INC.
MILWAUKEE, WISCONSIN

HenschelHAUS Publishing, Inc.
2625 S. Greeley St. Suite 201
Milwaukee, WI 53207
www.henschelHAUSbooks.com

HenschelHAUS books may be purchased for educational, business, or sales promotional use. For information, please email info@henschelHAUSbooks.com

ISBN: 978159598-695-5
E-ISBN: 978159598-696-2
LCCN: 2019930376

DEDICATION

This book is dedicated to Dusti Schiebe, who loved making photo books for other people. She was ahead of the curve in the photo book making world and delighted her friends and family with her work.

January 13, 1939 - May 12, 2018

Our Creative Memories team, led by Julie Uher and myself . . . we made many photo books back when the technology was very new. Dusti in the back row. She thrilled us with her stories and passion for having fun.

TABLE OF CONTENTS

FOREWORD

As Mollie's mother-in-law, it has been a privilege and a joy to watch this creative, passionate woman grow into a talented writer, entrepreneur, and Pixologist. Mollie's passion for helping people record their family history using the latest technology is endless.

The books she creates, or helps create, are timeless. They are enjoyed once completed and will never become less priceless.

A niece and I worked a whole year making a book detailing the history of her mother's and my husband's family. It is a process you do not want to rush. Creating that book was one of the most satisfying and fun things I have ever done, and in doing so, we made a lot of others happy. Without Mollie's insight and guidance, I do not think it would have ever been completed. I hope this guide will give you the confidence to do the same. Your story does matter!

A couple of years before Pixologie was started, Mollie worked with our family to create a photo book to celebrate my 80th birthday. I was amazed at the history, love, and traditions of our family that were contained, along with many wonderful photos. I like to feel that creating the wonderful

photo book for my eightieth birthday, accelerated Mollie's desire to capture the process for others to replicate... She has risen to the challenge and has been very successful with this venture.

However, I still feel MY book is her true masterpiece. Hmmm, I wonder what she will do for my ninetieth birthday?

—Eileen Bartelt

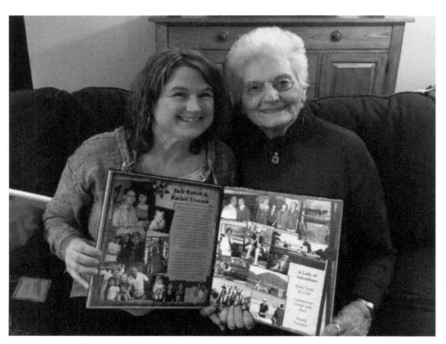

Mollie and Eileen Bartelt with Eileen's 80th Birthday photo book.
(You'll read about this later.)

Acknowledgments

My friend Ann Matuszak and I have had quite the journey into entrepreneurship with crazy, fun high moments and some horribly awful low moments. Through it all, Ann has been there for me as I wanted to write about the work we've done helping our photo organization clients save their memories. Much of the *Pixologist's Guide* series resulted from the work we've done together over the last ten years. And, her well-thought-out advice and in-depth knowledge of the technical side of our business has been incredibly helpful during the writing process. Thank you, Ann.

Then there are the many clients who have left our studio with amazing photo books that tell the stories of their lives. I couldn't have written this book if they hadn't entrusted their photos and memories to us. I hope you enjoy reading about many of their stories in this book as much as we've enjoyed bringing their digital photos to life in beautiful photo books. Because the stories are so personal, we feel almost a part of our clients lives and family as the book comes together.

I'd also like to thank Caroline Guntur, The Swedish Organizer, and our friend who helped read the book and offer some great ideas to make it better. Her work is inspirational to us and I am sincerely grateful for her assistance.

I so much appreciate my family, from my husband Paul to my kids, Hannah and Alex. They have had to live with an entrepreneur and author for a wife and mom. Not easy. They love me, forgive my shortcomings, and support me through it all. Lastly, my mother-in-law Eileen never hesitates to jump in and help around our studio and she always is cheering for us to keep saving people's memories. Her love of her photo books inspires me.

The Pixologist's Guide Series resulted from my initial meetings with Kira Henschel, my book publisher. I am very grateful that she has seen the value in helping people preserve their photos. Kira has been very patient with me as we make sure our books include all that we want them to say.

To you, the reader: Thank you so much for investing in this book. I hope you are ready to start your journey to creating photo books that preserve your family history, tell your stories, and treasure your values and traditions for generations to come.

—Mollie Bartelt
Co-founder of Pixologie, Inc.

INTRODUCTION

Years ago, I somehow managed to pull together the best gift ever for my mother-in-law, Eileen, when she turned 80 years old. I had made a couple of photo books here and there, but knew she needed something special—a keepsake she would treasure for the rest of her life. It was a photo book that chronicled her life and the impact she has had on those who love her.

I didn't create this photo book in a weekend. In fact, it took me many months to gather all the pieces together. But the resulting book included letters, photos, and stories from all of her family members. This photo book held dozens and dozens of stories, memories, moments, and pieces of history. A few weeks after her birthday party, my mother-in-law, Eileen, told me how often she looked through the book. She even had tears of joy at times.

Today, Eileen is 87 years old and still running circles around the younger generations. That book stays by her side in her living room and she continues to marvel at all that was captured in it.

The old adage is true: *a picture is worth a thousand words*. Now, imagine a photo book with pages and pages of photos, along with the words to tell the stories. There is no

better way to show others how much they are loved than by giving them the gift of memories in print. In this day and age, technology is stealing something away from us . . . the tangible feel of a photo album, the excitement of opening up an envelope of newly printed photos, the shared joy of looking back at memories in print.

Our ability to take photos has never been easier, but our capacity to do something with those pictures has never been harder. While we can take three to four hundred pictures at one short family event, we are unable to do much with those photos. I've worked with hundreds of clients over the years and witnessed their difficulty in doing anything with the large number of photos they've taken. Think of your digital photo collection. How many photos have you printed?

I am writing this book because I want to help people preserve their photos in a printed format. A printed format that is meaningful now and meaningful for future generations. As a Pixologist, I feel called to share what I have learned over the years in making hundreds of photo books for my family and other people.

WHAT IS A PIXOLOGIST?

You might be wondering about this word, "Pixologist." In 2013, my friend Ann Matuszak had an exciting idea to start a photo organization business. We had been selling scrapbooking supplies and photo book software for years. We knew clients needed hands-on help to finish their photo projects.

They loved our products, but were overwhelmed by decades of accumulated photos, both print and digital. By offering our clients photo organization services, we would truly make an impact in preserving memories.

I was sold on the idea and we started planning. Within three weeks, we settled on "Pixologie" as our business name. We loved it! *Pixologie . . . the study of life through photos.* One of my first clients, Bob Riley, began calling me his "Pixologist" after we organized and scanned 9,000 of his family photos.

Recently, Bob referred a 79-year-old retired attorney to me. When she called, she stated, "I need a Pixologist, too!" Since meeting Gen, I have organized and digitized nearly 10,000 of her family photos, including some that go back to the early 1900s. She and I are now working on four photo books to help celebrate her family's history and legacy. You'll get to see some of her photo book pages later on in this book.

So, what makes a person a Pixologist? Good question. Over the years, Ann and I have helped organize over 1 million photos. If you show me a photo, I can offer you three immediate things to do with it: Toss it, Save It, Share It. Sounds simple, but this is difficult to actually do with the hundreds and thousands of photos people accumulate!

In my mind, a Pixologist demonstrates the following characteristics:

- Knows how to organize photos efficiently and frugally (i.e., saving 15 to 20 of the 100 in a stack)
- Understands what photos will best preserve stories, traditions, and values for next generations

- Teaches people how to organize and save their own photos
- Offers photo organization, digitization, and archival tools that he/she has personally tested
- Provides custom solutions based on a client's technological know-how, time, and financial resources
- *Optional:* Works with family film and video preservation

Some of these services can be expensive. Both Ann and I believe that people should have the opportunity to preserve their memories, regardless of financial resources. Because of that, we have introduced "The Pixologist's Guide" series so that our systems of saving photos is available to everyone.

Our first book, *The Pixologist's Guide to Organizing and Preserving Family Photos* explains our system of helping people tackle their overwhelming photo collections. You may want to consider reading Book 1 if you have many old albums, boxes, and envelopes of photos to sort and preserve.

THE CHALLENGES PEOPLE FACE

Have you tried to start a photo book, but have not been able to complete it? Does any of this sound familiar?

- Literally, you have no idea where to start
- You aren't sure how to pick and edit the photos
- Your computer skills are shaky
- You have no time to work on the photo book

Don't worry, you are not alone. As a pixologist, I have seen some common challenges for people who want to make photo books. Some of these obstacles include time, technology, and a mess of photos. In a recent informal survey of people, I found that people need help picking photos, editing photos, using a website or software to make a book, adding text to pages and more. Sixty-six percent of respondents said they didn't know how to make a photo book.

In addition, I have noticed many nice, simple photo books at my clients' homes. Either they or their family make small one-off books with few to no words, just filling the book with wonderful, current pictures. Sometimes the books just cover one family event or photo shoot. These may contain many similar pictures being used to fill the twenty standard pages.

These are very nice mementos to cherish, but my system of creating a photo book offers a new perspective, one that will ensure your photo book tells so much more about your life. A perspective that gives you the know-how to make a book that will be treasured by future generations.

THE KEY TO CREATING A MEANINGFUL PHOTO BOOK THAT STANDS THE TEST OF TIME

I have a secret that makes it easy to help people create a great photo book. This secret ensures that your photo book tells a story, shares a legacy, and celebrates life.

Maybe you are looking for a simple book that doesn't require a large time commitment. That is okay, too.

The purpose of the book you're holding in your hands is to ensure that people know there is a another way to make a photo book. My secret is not special, not revolutionary, and uses a tool we learned about in grade school.

My secret is this: ***Create an outline for your photo book before you start.***

An outline helps you set the parameters of your project. It gives you a budget for ordering the book and ensures a starting point and ending point for completion.

To help you along the way, we'll be covering the following in this book:

- The anatomy of a photo book (construction, topics, themes, etc.)
- Different ways to create a photo book and review of software available
- Sample outlines for a meaningful photo book
- An overview of photo book industry

That said, I won't be reviewing the quality of photo books that different companies produce. My goal with this book is to provide information and resources about photo book printers so that you know how to make a photo book. Nor will I be discussing every possible size, shape, and type of photo book available. There are many resources to evaluate the different aspects of ordering photo books online. You'll find listed sites with extensive reviews In the Resources section.

My overarching goal in writing this book is to engage you in the process of creating a photo book and motivate you to

get started. My informal survey found that of those people who started a photo book, nearly eighty percent completed it. Once you get started, you won't want to stop until you are holding that beautiful printed photo book in your hands.

Throughout this guide, you'll see many examples of photo books. I also have handy downloads available to help you in your photo book creation process. You'll be able to access these downloads at **www.pixologieinc.com/photobooks**.

To demonstrate the photo book creation system I use, I will make a photo book to celebrate the life of my dad, David Hartmann, who died in 2015. While I am looking forward to having a book about his life, I sure wish we would have done it together when he was alive.

My hope is that more families will pull out their photos. They will have fun together reminiscing about growing up, being a young adult, and so much more. They will have keepsake photo books decades from now. Their stories will provide much joy and family heritage to future generations.

Some of my family members at Pixologie with the photo books that tell our stories.

CHAPTER ONE
THE IMPORTANCE OF FAMILY PHOTOS

P hotos provide a wonderful source of family stories. Sharing memories verbally is important and photos can jog forgotten moments. Looking at old pictures reminds us of many things that are forgotten as time passes. I am hoping that this chapter will motivate and inspire you in your photo book creation.

INSPIRE, CELEBRATE, STRENGTHEN AND CONNECT

In my work as a photo organizer, I have seen that photos can accomplish many things—when they are properly organized, digitized and shared.

Inspire – Think about the major accomplishments you've had in your life. Do you have photos of those moments? From graduations to climbing mountains and more, photos can help others be motivated to do something.

My daughter and I ran a 5K called the Color Run a few years back. It was supposed to be a fun day, with our cousins, Elisha and Kerry, visiting from northern Wisconsin with their

daughters, Kaely and Adrienne. However, Elisha's husband had passed away suddenly from a brain aneurysm just three weeks earlier. It was an immensely sad time for Elisha, Kaely, and all of us who had known him. However, Elisha wanted to do the run despite the tragedy.

When I look back at those pages of photos[1], I am struck by Elisha's strength in completing the run. We came together during a period of great sadness. These pages are inspiring and the moments show how we can get through true adversity.

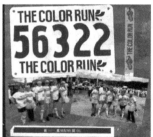

Celebrate – Of course, photos and photo books celebrate life. The major milestones we experience offer opportunities to look back and reminisce together. I've seen photo books for births, birthdays, adoptions, graduations, weddings, anniversaries, holidays, and many more.

It is important to recognize the traditions that are celebrated in your family. Every two years, my dad's side of the family gets together for a family reunion to catch up on all that families have celebrated.

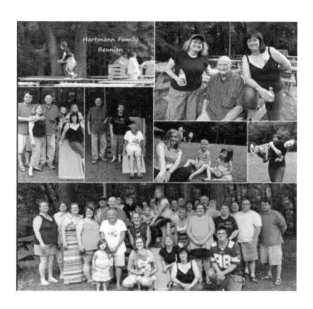

At Christmas time, my kids take part in our church's Christmas program on Christmas Eve. They have been baby Jesus, King Herod, narrator, Mary, and more.

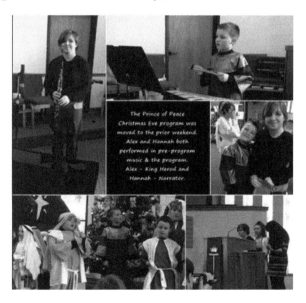

My dear friend, Bob Riley, and his family have another holiday tradition: each year, a different person is Santa Claus. With eight children and tons of grandchildren, year after year, their gift-giving photos and ever-changing Santas are so much fun!

Strengthen – I believe that photos can strengthen a family. When we take the time to remember the good and the bad times together, our emotional bonds grow. Deborah Gilboa, MD (also known as Dr. G.) says that "organizing and displaying photographs connects children to our families, our values, and our life goals for them."

She has pointed out that photos impact the three Rs of parenting: teaching **R**espect, showing **R**esponsibility, and building **R**esiliency. The events and experiences of childhood help children grow and develop strong values. Reflecting back on those moments is important. Parents reinforce what their children have learned when they look at pictures and talk about the memories. Each page focuses on telling your child (or someone else you love) what your hopes and dreams are for them.

The *I Hope book pages* shown opposite are great examples of how parents can pass on values to their children for living a good life as they grow up. (See more pages at www.pixologieinc.com/photobooks.)

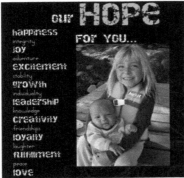

Connect – Now that photography has existed well over 150 years, a family might have pictures of ancestors from four or five generations ago. These photos are treasures and their stories need to be preserved and shared. Life back in the 1800s, early 1900s, mid-1900s, and even late 1900s, differs drastically from life today.

Children have greater feelings of connectedness and belonging when they see their parents and grandparents growing up photos. Imagine the impact children have today when fewer photos than ever are being printed. A full generation is growing up just looking at photos fleetingly on a device screen.

In addition, when completing a family history, photos are integral to telling a family's story. Photos add impact to family lineages by visually connecting generations.

FAMILY REMINISCING

Dr. Robyn Fivush started the Family Narratives Lab to study how memories influence childhood coping and more. From the Lab's website, "Her work focuses on early memory with an emphasis on the social construction of autobiographical memory and the relations among memory, narrative, trauma and coping."[2]

She and her research team believe that "Family reminiscing creates a shared history and helps to maintain emotional

bonds." In a recent article for *Psychology Today*, Dr. Fivush, stated, "Research from The Family Narratives Lab showing that children and adolescents who know more of their family stories show higher well-being on multiple measures, including higher self-esteem, higher academic competence, higher social competence, and fewer behavior problems."[3]

Back in 2001, Dr. Fivush and Dr. Marshall Duke, of Emory University created a list of twenty questions. These simple questions help parents talk about family history topics with their children. Can you answer these questions?

1. Do you know how your parents met?
2. Do you know where your mother grew up?
3. Do you know where your father grew up?
4. Do you know where some of your grandparents grew up?
5. Do you know where some of your grandparents met?
6. Do you know where your parents were married?
7. Do you know what went on when you were being born?
8. Do you know the source of your name?
9. Do you know some things about what happened when your brothers or sisters were being born?
10. Do you know which person in your family you look most like?
11. Do you know which person in the family you act most like?
12. Do you know some of the illnesses and injuries that your parents experienced when they were younger?
13. Do you know some of the lessons that your parents learned from good or bad experiences?
14. Do you know some things that happened to your mom or dad when they were in school?
15. Do you know the national background of your family (such as English, German, Russian, etc.)?
16. Do you know some of the jobs that your parents had when they were young?
17. Do you know some awards that your parents received when they were young?
18. Do you know the names of the schools that your mom went to?
19. Do you know the names of the schools that your dad went to?
20. Do you know about a relative whose face "froze" in a grumpy position because he or she did not smile or laugh?

My mother's uncle set off an explosion making moonshine.
There are some lessons in this photo!

Fivush points out that the historical questions aren't the important part of this exercise. Instead, it is the family discussions that come from starting the conversation.

First Things First, a non-profit that focuses on strengthening family relationships, writes "So, the next time your children roll their eyes during a story from the past, just remember that you are building what Duke and Fivush call 'the child's intergenerational self.' But that's not all. You're also increasing their personal strength and giving them moral guidance."[4]

Photo books can be great conversation starters. Family stories have great power. Give the children in your family a strong head start in coping skills, building self-reliance, and resiliency with family stories.

LEAVING A LEGACY

This past year, I met a family estate attorney, Giff Collins. He enjoyed learning about how we've helped people save their photos. He described how his goal for estate planning included ensuring that families have cohesion after the death of a loved one. He mentioned "estate planning is important to help strengthen relationships before someone dies." I was struck by his words and we both agreed, photos are an important part of a loved one's legacy.

With twelve aunts and uncles on his father's side and seven on his mother's side, Collins acknowledged there are many family dynamics. Sometimes the drama can impact relationships for the long term. A parent who plans his/her financial legacy helps the family avoid much additional anger, grief and more with advance thought.

Collins said something to me that really made me think. He said, "Often, without proper advanced planning, within eighteen months after a person has passed away, the inheritance is gone." There is usually at least one generation within a family, that starts in the middle class, works hard and has the discipline to accumulate wealth. After creating the wealth, with proper planning, future generations can accumulate

more and live comfortably from the income the wealth generates. However, inheritances sometimes end up being spent on home remodeling, vacations, debt payoff and many other big-ticket items. To avoid the inheritance being wasted, it helps when the family knows how hard previous generations worked to accumulate the wealth for the next generation's benefit. Collins continually works with families to help ensure families can maintain their legacy.

It's the same with your photo collection. Plan to pass on the photos and stories in an organized manner so that you can leave more than just a financial legacy for your family. Whether you are leaving a small or large inheritance, the family stories, photos, memories and more are just as important to pass on to future generations.

Photo books offer an amazing way to preserve family legacies, histories and stories. Collins encourages his clients to consider having their photo collections preserved as a part of the estate planning process.

FINAL THOUGHT

Photo books have the power to give the children in your family a strong head-start in coping skills and strengthening their values. They help cement your family legacy and tell your family's stories for generations to come. I hope this chapter inspires you as you move forward in creating your photo book.

CHAPTER TWO
ANATOMY OF A PHOTO BOOK

A photo book is different than a photo album. Many families have dozens of photo albums, the precursor to photo books. In fact, some of my clients have mentioned they don't need to create a photo book; they'll just slide their photos into an album. Before I dive into the anatomy of a photo book, here are some pros and cons regarding both the photo album and the photo book.

Photo Albums

Pros

- Can easily slide photos into the sleeves in some cases
- Fast, easy, and often inexpensive
- Require little to no planning

Cons

- Probably not photo safe (think of all those magnetic albums with discolored photos!)
- Accumulate and take up a lot of space
- Don't match
- Contribute to a cluttered, disorganized space

- Your children and grandchildren probably don't want to keep them
- Some notes might exist in the albums, but most people don't the time to journal in photo albums
- Many of the pictures are repetitive or just bad; and don't need to be saved
- Photos at risk of falling out in some cases

Photo Books

Pros

- More compact for storage. A 50-page photobook takes less space than a 30-page photo album.
- Visually appealing. Family photos can be on the cover.
- Easy to duplicate; make additional copies for other family members
- Text or journaling is easily added
- Photos can very in size depending upon importance

Cons

- Take a little to a lot more time for creation
- Probably will cost more than a photo album

With photo books, you will find it much easier to preserve your family's stories. Do you treasure your old collection of photo albums? Consider taking the photos out of the albums Digitize the important photos. Create more meaningful photo books to share your memories with each other.

COMPONENTS OF A PHOTO BOOK

Next, let's talk about the parts of a photo book.

Size and Shape
Each photo book company differs with regard to the sizes of books they will print. Photo book sizes range from:

Square Books
- 6 x 6-inch board books, great if you want to make a children's book
- 7 x 7-inch – pretty small yet
- 8 x 8-inch – I like this size for quick photo books given as gifts to celebrate a special occasion
- 8.5 x 8.5-inch – not common
- 10 x 10-inch – my favorite size., not too small and not too big!
- 12 x 12-inch – traditional scrapbook size; great if you have a lot of pictures you need to fit in the book.

Rectangular Books
- 8.5 x 11-inch landscape – the size of a sheet of paper; it's a common size
- 8.5 x 11-inch portrait – this is typically the size of year-books, church directories, etc.
- 11 x 14-inch landscape
- 11 x 14-inch portrait

This is just a sampling of sizes; there are many more available.

I prefer to make square-shaped photo books. If you need copies of a photo book made, the square shape can be ordered in many different sizes. For instance, with a family history book, you may want a 12 x 12-inch copy for your elderly relative who may have vision problems. And, for the younger family members, a lesser expensive, smaller 8 x 8-inch copy might do the trick.

TIP: If you think you are going to order a book in more than one size, always start making it in the largest size possible. That way, if you shrink the pages, you are starting with the highest quality of pages. (If you start small and enlarge the pages for a larger book, you could reduce the photo clarity of the pages.) You may be able to reduce the size of pages in the ordering process.

Number of Pages

Typically, photo books will come with a standard 20 pages. Most photo book companies will offer a maximum of 100 pages. Additional pages are extra and can be costly, from $1 to $4 per page. By planning your pages out in an outline, you can determine what your costs will be. It can be quite shocking when you have many extra pages but hadn't planned on the additional expense.

I have seen people take advantage of huge discounts at major print book providers, only to find out the discount doesn't apply to the extra pages. Be aware when you are

looking for the best deal. You'll want to make sure the price covers extra pages.

Here's an example from Shutterfly of the cost breakdown of a 41-page book showing that the pages are also on sale.

FREE SHIPPING on orders $49+ Code: SHIP49		
Ends Tues, Nov 13 SAVE 50% ON ALMOST EVERYTHING* no code needed		
20-page 10x10 book	$29.99	$15.00
Hard photo cover	$20.00	$10.00
Standard pages		$0.00
21 Additional pages	$43.89	$22.05
Total	$93.88	$47.05

Cover & Paper Quality

In addition to choosing sizes, you'll also have options for the cover and for the type of paper used. As the quality goes up, so does the price. Here are some of the options you may come across:

Cover

- Soft Cover
- Hard Cover
- Matte print
- Glossy print
- Leather Cover
- Dust Jacket (I don't like these because they damage easily and can be lost!)

- Other premium materials, like acrylic,, silver halide, etc.— generally for high-end photography and wedding books

Pages / Paper

- Standard – pages are folded as they go into the binding.
- Lay Flat
- Lay Flat no gap/Flush mount
- Matte print
- Glossy print
- Gilded edges

The photo below shows two photo books. The bottom one is a "lay-flat" book, while the top is a standard book. In the lower book, you can see how the pages are folded (rounded) in the center and some of the photos are lost into the binding.

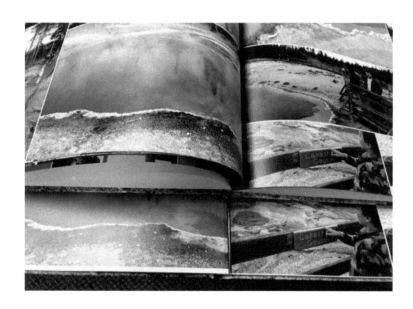

Often, print providers will also sell deluxe gift boxes in which to store the photo book.

One other point about the cover. I believe covers should be customized with your photos and title. Some photo book providers offer an option for a cloth cover or cloth cover with cutout window. This is wasted space, in my opinion.

There are many higher-end options. You can order custom photo books with heavy press board, moleskin, or wood covers. Pages can also be made of heavy pressboard, gilded, etc. Generally, consumers will not be ordering this type of photo book. But it is fun to see the many options available. Some providers offer sample books.

Binding

What keeps the pages of your photo book together? By choosing the right binding option, you'll improve the durability and longevity of your photo book.

- Stitch Binding – the pages are sewn together along the fold and generally are stronger. (Also known as "Smythe sewn" binding)
- Adhesive Binding – the pages are glued together. The type of adhesive process used depends on the manufacturer.

We recommend stitch binding whenever asked.

Photo Book Themes/Design Templates

What theme do you want to you use with your photo book? There are many, many options from simple to ornate, from trendy to scrapbooky, and much more. Some of the design depends upon your personal style. Or, it might depend upon the style of the person who will be receiving your photo book as a gift.

Depending on which method and photo book provider you choose to create your photo book, you may come across the following:

- **Themes** – a general design, look and feel for a photo book. Pages are predesigned to coordinate. Themes can include festive, holiday, traditional, nostalgic and much more. All online photo book providers offer free themes.

- **Predesigned Pages** – These design templates generally refer to photo book software. The page designs are exclusive content to that software developer. Some predesigned page kits are free and others must be purchased, but they can be used over and over again.

- **Content** – Refers to paper, embellishments, typesets, etc.. For instance, with some software programs, you buy purchase kits of themed paper, embellishments including sayings and more.

Examples of themes available at Snapfish.com:

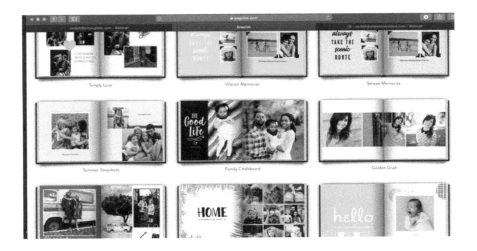

Examples of predesigned pages available at mymemories.com:

Examples of content available at Forever.com designed by pixels2pages.net:

Life Lessons Crop Kit	January Jamboree Cr...	Globe Trotters Crop Kit
$9.95	$9.95	$9.95

An advertisement for Forever.com's digital content:

Now that you are acquainted in what characteristics photo books can have, let's start thinking about how to actually create a photo book.

Steps to Creating a Photo Book

When I talk to clients about making a photo book, these are the general steps I follow:

- Pick your topic
- Gather your photos, memorabilia, etc. into a digital folder on your computer
- Create an outline
- Choose a photo book printing company and/or photo book creation software and/or photo book printing
- Create the book
- Order the book
- Enjoy!

The next parts of this book will describe each of these steps in detail.

Some of our clients and friends looking at photo books at a recent Pixologie event.
So many possibilities! Where to start?

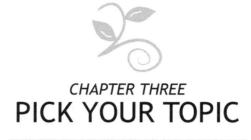

CHAPTER THREE
PICK YOUR TOPIC

While visiting clients' homes, I have seen many photo books they have received as gifts. With the deals online and even at your local pharmacy, it can be simple to make a quick photo book. If you need a photo book gift in a hurry, by all means, get it done quick and easy.

If you want your photo book to tell a bigger story, I offer these suggestions:

- Thoughtfully consider what you want your book to say about the topic
- Take time to jot down notes (typing is better)
- Ask other family members if they have relevant photos or information that might be important to include
- Consider the durability of the book type you choose

Here are a variety of topics to take into account . . . and my formula for each. The formula includes the number of pages, photos, and items needed. This will help you decide what amount of time you need to invest gathering the photos and memorabilia for each idea.

Family Year Book

Over ten years ago, I met a couple from my church who had already started making annual digital photo books for their family. Now, I enjoy making a photo album for each year to include the best pictures and moments we shared together. (Confession: I am not exactly caught up on my family year books!)

My formula: Plan for around 50 pages. Include approximately 300 photos, four to six per page, with one journaling box to highlight the events in the photos. You don't have to include every moment from the year, just enough to remember the important times and who was there.

Need to know which photos to save for this project? Go to our website, www.pixologieinc.com/photobooks and download "Which Photos To Save"

Options: Create a photo book for two years or five years or perhaps even a decade.

Family History Book

Would you like to have a photo book that tells the history of your family? These are some of my favorite books to help design. Typically, you'll have your parents' and grandparents' photos in the book, along with stories about your heritage. Photos and memorabilia include immigration papers, military service documents.

If this is on your to-do list, be sure to interview your older family members as soon as possible so that you can identify who is who in the pictures.

My formula: 30 to 40 pages depending upon the size of your family. 150 to 200 photos; 10 to 20 pieces of memorabilia; letters from each significant family member.

Options: Consider doing one book for each side of the family; Perhaps focus on one family member in particular.

SPECIAL EVENT BOOK

Chances are good that you have someone celebrating a milestone birthday in your family in the near future. The gift of photos and memories is priceless. Graduations and anniversaries are also special times to reminisce together.

My formula for a simple Special Event Book: 20 pages, 60 to 80 photos, headings for each page

My formula for an in-depth Special Event Book: 30 to 50 pages. 150 to 200 photos, 10 to 20 pieces of memorabilia; letters from each significant family member.

Photos—even just one or two photos from each of the following categories will be great:

- Baby/childhood if at all possible
- Teens/young adulthood
- Hometown/high school/church
- Significant life events
- Memorabilia, marriage certificate, passport, etc.
- Artwork, awards
- Personal letters to the recipient/s are VITAL to making the best gift ever!)

Option: For a graduation party. Include sign-in pages in the book. Some pages contain the funny stories, photos and letters with blank pages for guests to write in the actual book.

ACCOMPLISHMENT BOOK

Accomplishment topics range from sporting feats to musical achievements and more. There are many ways to go with this type of book. I find its more meaningful to include many years of working at the particular accomplishment.

My formula for a simple Accomplishment Book – 20 pages, 60 to 80 photos, headings for each page

My formula for an in-depth Accomplishment Book 30 to 50 pages. 150 to 200 photos, 10 to 20 pieces of memorabilia; journaling about some of the events and thoughts you have on your person's accomplishment.

Options: You could again go for a simple book by just focusing on one short period of time. Or, you could create a book that covers years of skills development and participation in events.

CELEBRATING A LIFE

For my own family, I have created books to celebrate someone's life after they have passed away. It is especially sad when you realize the person is no longer around to share the memories in the photos. It is so much more fun to have a photo book done while your older family members are still alive!

My formula: 20 pages. 50 to 80 pictures from childhood, young adulthood, having a family, career, interests, retirement, etc. Maybe a couple pieces of memorabilia.

Creating this photo book is a tremendous way to honor the memory of your loved one. And, ordering is easy for each family member who'd like a copy.

TRAVEL BOOK

So many people invest time and money to travel, yet they don't take the time to celebrate where they've been! I love making travel books for my children to look at. There are so many things you could record about where you've been:

- The history and background of where you were
- The funny moments on the trip
- Why you went
- Who you traveled with and why

For my children, the travel books are proof we were good parents and actually did something meaningful on summer vacations. (Sometimes I worry about that!)

My formula: 20 pages for a smaller vacation; 30 to 40 pages for a larger trip; photos and memorabilia from the trip.

Options: Include multiple trips in one book (Been to Mexico more than once? Combine the trips into one book since some of the photos might be repetitive.)

RECREATING A FAMILY SCRAPBOOK

Occasionally, I have had clients who wish to digitize a family heirloom scrapbook or even a scrapbook that has been recently made. You can scan your pages and then upload to a photo book printer that allows full page uploads. (meaning you don't have to use their design templates.) More on that later!

Following are a few pages from my mother's scrapbook that I scanned. I don't think I'll be making an exact replica of the book because I really don't need to save all the photos (like the bear and the tree and the bad party photo!) I am

torn, though, because it is great to have her handwriting. Someday, when my mother is gone, I may treasure that. However, some of our clients have wanted to exactly reproduce their old family scrapbooks.

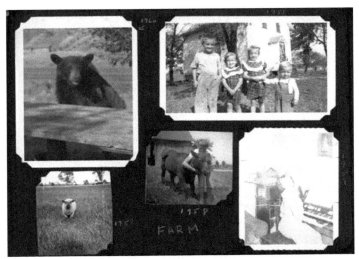

Pages from a family photo album.

By now, your head is probably spinning with ideas and possibilities for photo books. You must now settle on a topic for your photo book and start gathering your pictures.

A word of advice: If you are not sure you have the photos for your project, consider reading Chapter 4: Create Your Outline first. Think about your organizational skills and the number of photos and memorabilia you have. These may affect your topic decision.

Bonus Ideas

Our colleague, Caroline Guntur, The Swedish Organizer, also suggests these ideas for a photo book:

Recipe books – Create a book with treasured family recipes and include photos of the family members who loved to cook and bake. We actually helped a client recreate a recipe book from the 1940s that had a recipe for possum! How amazing to include our client's grandmother's handwriting in the book!

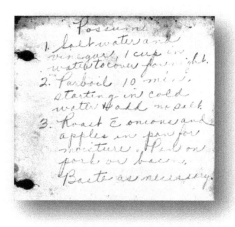

Memorabilia Books – Create books with different pieces of family documentation, old holiday or birthday cards, ticket stubs, school projects, artwork and much more.

CHAPTER FOUR
CREATING YOUR PHOTO BOOK OUTLINE

remember learning how to outline a chapter in Social Studies back in grade school. Doing so enabled us to know the important parts of the material and what to study for tests. Funny, now I am using the process in reverse. . .and telling you to create the outline first.

I began using outlines when I scrapbooked. I don't honestly remember when or why I began doing it, but it has proven to be extremely helpful through the years. I think I just didn't want to run out of room or pages.

Once I started helping other people with their photo books, an outline became an essential tool. I realized that people often didn't know what their photo book should or could contain. I met with them to review their notes, photos, memorabilia, and other materials. Then, I would write the outline to capture all that we spoke about. By having the client review the outline, we could make needed adjustments. Once the outline was completed and approved, I knew my client and I were on the same page.

Author Lynn Serafinn shared reasons why an outline is important for getting a book written.[1] We aren't writing a

book necessarily, but the principles still apply. Here are her thoughts about creating an outline that especially resonated with me:

- It makes writing easier
- It makes reading easier
- It makes sure you are thorough
- It helps limit continuity errors
- It makes sure your book has symmetry and balance
- It helps keep you focused
- It helps motivate you

I also want to add to her list. Creating an outline helps you search for photos, eliminates duplication, and makes sure you don't go over your budget.

In the sections that follow, I provide sample outlines for photo books. You can use the outline exactly or modify it for your purposes.

BASIC PHOTO BOOK OUTLINE TEMPLATE

Using this template is the simplest way to start. All you need to do is write on each page what photos and text you want to go on the page. You can also download this template at **www.pixologieinc.com/photobooks**.

Page 1 – Usually a title page

Pages 2 – 3_____

Pages 4 – 5_____

Pages 6 – 7 _____

Pages 8 – 9_____

Pages 10 – 11_____

Pages 12 – 13_____

Pages 14 – 15_____

Pages 16 – 17_____

Pages 18 – 19_____

Page 20_____

If you have more pages, just keep adding lines.

As you are gathering photos, make a file folder for each page and place the items in those folders. It's best to keep collecting items and then scan all at once if possible. Your ultimate goal is to have a digital folder with all the pictures contained in one place. (Your digital folder can have subfolders for pages if you desire.)

Using this template, I have created an outline for my dad's photo book here:

Page 1	Title Page – David Hartmann
	Through the Years
Pages 2-3	Childhood photos with siblings
Pages 4-5	Teens and high school
Pages 6-7	Serving in the Military
Pages 8 -9	Meeting Mom

FAMILY HISTORY BOOK OUTLINE

How many old photos, documents, and memorabilia do you have? A family history photo book could be an amazing testament to who and where your family came from. Susan came to us because she had a tremendous amount of information, photos, and memorabilia. I still remember the day she arrived, tote in hand. As she kept pulling out more certificates, immigration papers, old photos, jump drives of photos, and more, I knew she was in desperate need of outline help.

Susan's vision for the family history book included a lot of interesting narrative. Her outline was far more extensive than the simpler version I am listing here. I created a table with a column for the page numbers, column for the photos and memorabilia and a column for the paragraphs she wanted to go on each page. Her book title was "Our Family Heritage" 1850s to 1930s.

- Page 1: Cover page – A New Beginning in America; photos from late 1800s
- Pages 2 – 3: Our German Roots – photos and narrative / Anton & Anna Griebling
- Pages 4 – 5: Greiblings Immigration to America – travel documents, etc.
- Pages 6 – 7: Citizenship & Census / Civil War Service
- Pages 8 – 9: Life in the Late 1800s / Other Documents
- Pages 10 – 11: Ludwig Matz / Catherine & Ludwig
- Pages 12 – 13: More on Ludwig and Catherine / Photos, diary excerpts, newspaper clippings
- Pages 14 – 15: Gertrude's Diary & Scrapbook / Paula Matz Childhood
- Pages 16 – 17: Paula Matz as young adult / Oscar Matz – Favorite Uncle
- Pages 18 – 19: Paula & John Treuden / The J. Treuden Delicatessen
- Pages 20 – 21: More Photos of Matz & Treuden Families / Memorabilia, antique cards shared
- Pages 22 – 23: Ruth Treuden / photos, memorabilia
- Pages 24 – 25: More about Ruth / report cards / Family Tree Other Photos
- Pages 26 – 27: About Grace – Church records and stories
- Pages 28: Bringing History Together – photos of the family working on the history together

Read Susan's full family history photo book on our website and view her outline by going to **www.pixologieinc.com/photobooks.**

When Susan started the project, she mentioned that her mother was going to be 100 years old soon. I felt a sense of urgency to complete the book as soon as possible. Susan's work and documentation with her mother were amazing. Her mother enjoyed reading the book when it was completed.

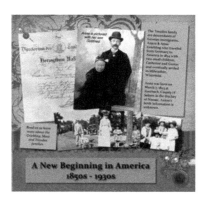 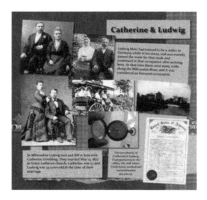

Have you asked your elderly relatives all the questions about your family history? If not, I hope this encourages you to talk with them soon. The questions on page 15 are a good place to start. Consider recording (audio / video) the conversation to capture all the details.

Options:
- Focus on one side of the family if necessary.
- Create a Family Who's Who Book with each family member detailed
- Family tree

FAMILY YEAR BOOK OUTLINE

If you follow my formula for a family year book, you may not need to use an outline. I included an outline from my 2015 Family Year Book just to give you an idea of what it contained.

I generally tried to keep events (like a birthday or holiday) to one page if possible. This does mean you have to pick and choose photos carefully. I generally select way more than I will be able to use. Once I am working on the actual photo book page, I can adjust size and layouts as needed while picking the best pictures to fit on the page.

- Page 1: Cover page – Bartelt Photos 2015 - Highlights from Our Year – my three favorite photos
- Pages 2 – 3: Tai Kwon Do photos / Trip to Demarini's Pizza (a family tradition)

- Pages 4 – 5: School Honors Day, Valentine's Day / February and March photos
- Pages 6 – 7: Admirals Games, Painting at Sister's / Day at Sky Zone Trampoline Park
- Pages 8 – 9: Tai Kwon Do photos, pet pictures / Easter photos
- Pages 10 – 11: Road trip with sister / Just Add Kids Expo fun time with kids
- Pages 12 – 13: Tai Kwon Do Belt Testing / Day with Friends
- Pages 14 – 15: May Moments Soccer, band / Alex learns to ride his bike
- Pages 16 – 17: Alaska Trip Photos (*just two pages worth – I actually made a separate album for all the other photos!*)
- Pages 18 – 19: Family Reunion / Summer Doings
- Pages 20 – 21: Water Park / Girls day out
- Pages 22 – 23: State Fair
- Pages 24 – 25: Celebrating my dad's birthday / day at the beach with friends
- Pages 26 – 27: Back to school photos / September Doings
- Pages 28 – 29: Aunt's Birthday Party / Halloween
- Pages 30 – 31: Leaves and dogs / November Doings
- Pages 32 – 33: First snowfall and dogs / Thanksgiving
- Pages 34 – 35: Christmas Cookie Walk at church / Maria's Pizza (another family tradition)
- Pages 36 – 37: Wishes in Wonderland Charity Event / December Doings
- Pages 38 – 39: Christmas Eve Program at Church / Holiday lights with my sister (both family traditions)
- Pages 40 – 41: Christmas Eve at Grandma's / Christmas Morning opening gifts
- Pages 42 – 43: Christmas Day events / New Year's Eve
- Page 44: In Memory of My Dad – who died in October of this year

As I look over this list, I notice how many of the pages actually represent the traditions of our family, some carried down from a generation or two ago. Here are a few pages from my 2015 Photo Book. (Nerf guns and the Flynns are a huge part of my life, Maria's Pizza is a family tradition, and we all enjoy Halloween!)

Pages from Ann's Family Year Photo Book for 2013.

SPECIAL EVENT PHOTO BOOK OUTLINE

Celebrating a birthday, graduation, wedding, or anniversary is more fun with a photobook. Such a book provides many fun memories and laughter. Consider adding text to the pages to share the stories. You may also want to have other family members contribute photos and a letter to the book to really make a lasting gift.

This is the outline I used for my mother-in-law's 80th birthday book.

Title: Celebrating 80 Years - Eileen Bartelt

- Page 1: A couple of her key photos through the years & a note about her birthday – signed "With all of our love, Your Family"
- Pages 2 – 3: Photos of Colfax, her parents and early childhood through high school
- Pages 4 – 5: Young Adulthood, meeting Richard Bartelt, wedding, Starting a Family
- Pages 6 – 7: Son #1's Pages – Through the years and adult photos; letter from him and his wife
- Pages 8 – 9: Grandson #1 Page – Note and photos; Grandson # 2 Page – note and photos
- Pages 10 – 11: Daughter Pages – Favorite Memories narrative; through the years photos and current pictures
- Pages 12 – 13: Son #2's Page – Photos through the years; Granddaughter's Page – photos and letter
- Pages 14 – 15: Grandson #3's Page – note and photos; A Lady of Adventure Page – photos (Career, Laborers, World Traveler
- Pages 16 – 17: Son #3's Page; Daughter-in-Law's Page

- Pages 18 – 19: Granddaughter #2's page with photos, letter; Grandson #4's page – with hand drawn note, photos
- Pages 20 – 21: Niece #1's Page, photos and Letter; Niece #2's page, photos and letter
- Pages 22 – 23: Grandniece page, photos and letter; Grandnephew page, photos and letter
- Pages 24 – 25: Niece #2's Page, photos and letter; she actually took two pages!
- Pages 26 – 27: Brother's Pages – photos, letter from his whole family
- Pages 28 – 29: Family Tree – Harvey & Freida Harms (her parents)
- Pages 30 – 31: Extra Photos
- Page 32: Extra Photos with the center one of her when she was in her 30s by a stream in the woods

Here are other options for pages:
- Certificates, documents, diplomas
- Anything significant from back in the day (a pay stub from a job; etc.)
- Military service recognition if applicable
- Newspaper articles

Even one or two photos from each of these categories will be great addition to your Special Event book.

- Baby/childhood if at all possible
- Teens/young adulthood
- Hometown/high school/church
- Significant events (sports, wedding, major trip) of family – early, growing up and adult photos

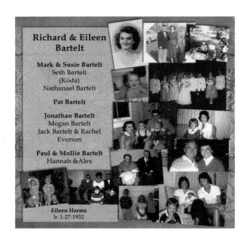

TRAVEL PHOTO BOOK OUTLINE

Over the years, I have created quite a few travel photo books and each one has turned out differently. An easy way to outline this book is to choose a page or two for each day of the trip. When you travel, it is helpful to write down a few of your thoughts at the different places you visit. You can also grab a postcard, brochure, or flyer with information as well. These items could potentially be scanned for the photo book.

Be sure to have you and your family or friends photographed in front of major landmarks and other special places. Avoid landscape scenes that are repetitious if possible.

Here's a sample outline for a photo book. It's pretty straightforward. On pages 4 through 19, if you plan an average of four pictures per page, you'll need about 56 photos from the trip. If you can't narrow it down, simply add more pages.

- Page 1: Title Page – two of your favorite photos from the trip (with you or your family in the pictures!)

- Pages 2 – 3: "Getting there" photos. (One or two on the plane if this is something you rarely do; outside the plane window, etc); Room accommodations possibly – with you in them. No need for photos of the empty hotel room

- Pages 4 – 5: Day One – photos and description of activity, location, etc.

- Pages 6 – 7: Day Two – photos and description of activity, location, etc.

- Pages 8 – 9: Day Three – photos and description of activity, location, etc.

- Pages 10 – 11: Day Four – photos and description of activity, location, etc.

- Pages 12 – 13: Day Five – photos and description of activity, location, etc.

- Pages 14 – 15: Day Six – photos and description of activity, location, etc.

- Pages 16 – 17: Day Seven– photos and description of activity, location, etc.

- Pages 18 – 19: Last Day – photos and description of activity, location, etc.

- Pages 20: Wrap-Up Page

Optional Pages

- Top Ten Moments of the Trip
- Full page of best pictures

Below is our "Getting There" page as we road-tripped it to Yellowstone National Park. In the next photo book page on the bottom, my son is completely ignoring the buffalo, which were very far away. Instead, I enjoyed snapping a few photos of him balancing on the log. Okay, this was repetitious, but even I get caught up in my cute kid photos!

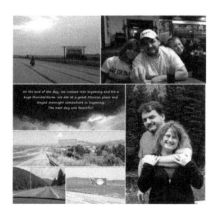

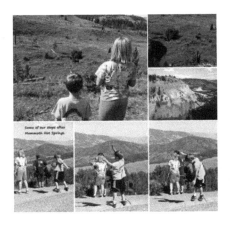

Other Ideas for Travel Photo Books

A photo book with photos only! For one of my clients, I felt the best design for her travels to Vietnam and Thailand was a simple approach. No colorful themes, just her photography. See the Client Stories section for more about her books.

If you enjoy photography, consider using the "Gallery" approach to a photo book and let your images be the main focus of every page.

ACCOMPLISHMENT PHOTO BOOK OUTLINE

You might be celebrating a graduation, retirement or significant achievement (like becoming an Eagle Scout, for instance). A photo book is a special way to reflect on the work it took to get there.

For the sample outline here, I am going to share my client Gen's Career photo book outline. She retired after an amazing

40-year career with a Chicago bank. The company paid for her education to become an attorney, which she achieved after 13 years of night school.

- Page 1: Title Page – young photo and retirement photo; her name plate
- Pages 2 – 3: 1955 Graduation from high school and first job photos / college bachelor's degree diplomas and photos
- Pages 4 – 5: Bank Career photos, brochures with her writing, photos / Juris Doctor degree and newspaper article "Lady Lawyer Did it the Hard Way"
- Pages 6 – 7: Law Degree memorabilia, photos, company newsletter announcement and other documents
- Pages 8 – 9: Company "Woman's Business" pamphlet with an article written by her / full page photo in the law library
- Pages 10 – 11: Thoughts from client and church service work / running for school board – 1970s and 1980s photos
- Pages 12 – 13: Moving up the corporate ladder. Promotion letters to Vice President; newspaper article / Photos from bank dinners
- Pages 14 – 15: 25th Anniversary at bank in 1988 – photos, documents; notes of congratulations
- Pages 16 – 17: 25th Anniversary speech with more photos / etc.
- Pages 18 – 19: 30-year anniversary notes, photos, poem / Co-worker celebrations - photos
- Pages 20 - 21: More co-worker celebrations and moments
- Pages 22 – 23: Retirement Party, Dinner and Family Gathering
- Page 24: Service Work after Retirement – photos, stories

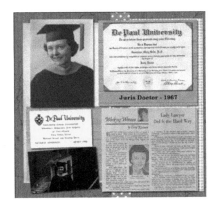

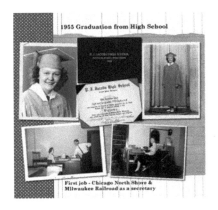

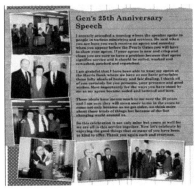

COPYRIGHT THOUGHTS

You do need to be careful to not use copyrighted materials. This includes professional portraits, articles and other items. When you order a book online, be sure to check out the Terms of Service located on the print provider's website. You are agreeing to a variety of policies including that you own the right to reproduce the materials in the book you are having

printed. If you are not planning on selling copies of your book, your use of the material may fall under "Fair Use."

> **FAIR USE**
>
> Fair use is a legal doctrine that promotes freedom of expression by permitting the unlicensed use of copyright-protected works in certain circumstances. Section 107 of the Copyright Act provides the statutory framework for determining whether something is a fair use and identifies certain types of uses—such as criticism, comment, news reporting, teaching, scholarship, and research—as examples of activities that may qualify as fair use. (2)

Other Page Ideas:

- Career Travel – some people are fortunate to see many new places as a result of their work.

- Invention/Patent – if applicable

CELEBRATING A LIFE

I wish that everyone could reminisce over old photos before a family member passes away. Wouldn't it be great if you had already organized and saved the photos that tell the stories of a person's life? I have done a few remembrance photo books and they are very special.

Here's the outline for one I did when my father-in-law passed away. He's been gone a long time now, but when I look at these photos, I feel like I can hear his voice and just saw him yesterday.

- Page 1: Title Page – Highlights from Dad's Life
- Pages 2 – 3: Baby photos / young child photos
- Pages 4 – 5: School pictures, newspaper articles / teenage years – Bible verses
- Pages 6 – 7: Dad and Mom Meeting / The letter asking for Mom's hand
- Pages 8 – 9: The Wedding / Our Growing Family
- Pages 10 – 11: Fun times with kids and the postscript arrives (a baby fourteen years after the last child!) / The Bartelt Home – building and bible verse
- Pages 12 – 13: Grandchildren
- Pages 14 – 15: 42 Years at the Electric Company / Camping Memories
- Pages 16 – 17: Traveling Memories / Photos with Mom etc.
- Pages 18 – 19: Laborers for Christ volunteer and service work
- Pages 20: "Well done, good and faithful servant" wrap-up page

On the night before their wedding, my father-in-law was in a car accident, car totaled, and he may have had a concussion at the wedding. You couldn't tell this by the photos, and if we hadn't written this in the book, no one would know. Now, is it an important detail? Maybe not, but it's an example of getting through adversity in life. We covered the importance of storytelling at the beginning of this book. I do believe it is another example to show how we all get through life. The grandkids will find this fascinating!

Here are a few pages from his book:

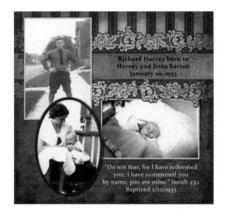 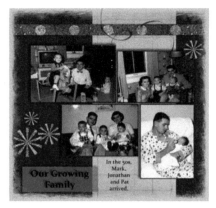

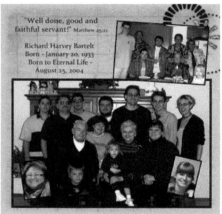

The bible verses show that my father-in-law's faith traveled with him throughout his life.

What story do you want your photo book to tell? Throughout this chapter, I have provided many ideas and examples. Now, it's up to you to write your outline, and then gather your photos.

THE BOOK COVER

As you plan your outline, you can start thinking about what will go on the cover of your photo book. I normally leave this to the last of my photo book project. Then, I will have seen all that has gone into the photo book. I pick the best photos that represent the story to go on the front cover. In some cases, you will also be able to design your back cover. I like to put extra photos on the back cover that couldn't fit into the book.

The title of the book will also depend upon the topic you choose and the overall feel of your book. It can be very basic or descriptive.

Here are some titles I have used:

- Our Trip to St. Louis
- Our Family Memories
- Gen's Career Book
- Mary Drew Drive Memories
- Through the Years

As creative as I can be, you can see the titles are pretty basic. Here are some covers of different books I have done. You are looking at the front and backside as one graphic. (So the front of the book is actually on the right half, the back is on the left half. Depending upon the size of the book and provider, I have added a title on the spine of the book as well.)

Some cover examples:

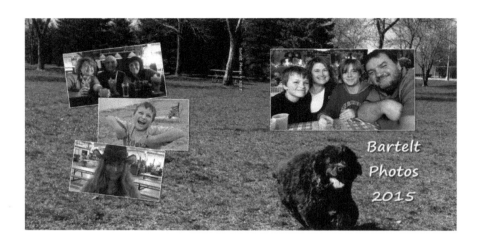

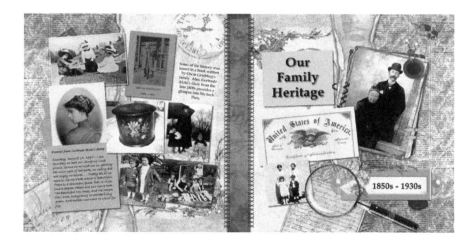

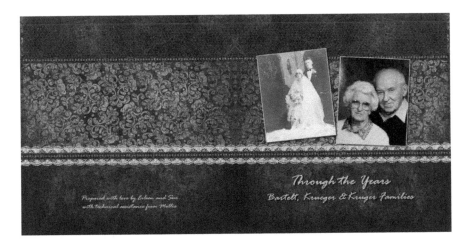

Note the "Prepared with love by Eileen and Sue with technical assistance from Mollie" on the back. That is a nice touch, similar to the "made with love" you see on homemade cards sometimes!

CHAPTER FIVE
GATHER YOUR PHOTOS

To make a good photo book, you want to cover all your bases. That means finding all the photos, documents, and memorabilia necessary to tell your story well.

I've mentioned memorabilia a few times. Here's what that might include:

- Documents
- Certificates (immigration, naturalization, wedding, etc.)
- Newspaper clippings
- Awards
- Funeral prayer cards

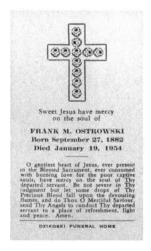

- 1900 Census

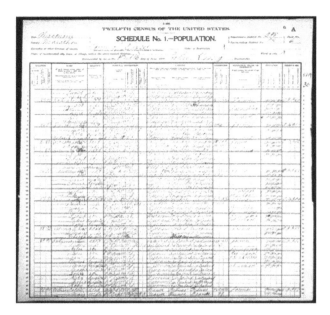

- Newspaper article included about being a carrier boy

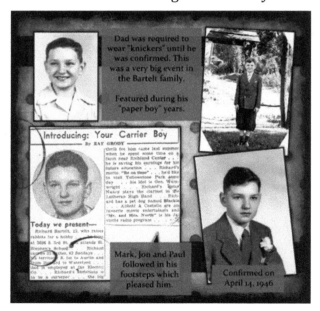

Use a Filing System

You've made your photo outline. Now, let the outline help you organize your project. When I have a large photo book project, I like to use file folders for each page or set of pages to get organized.

As you gather the printed photos and other items, place them in a folder corresponding to the page numbers. If you are working with digital photos, you can create digital file folders as well.

Also, as you are creating your outline, you may want to jot notes down about each set of pages. . . a narrative of points you don't want to forget as you go along. I sometimes start a Word document to record different notes and thoughts I want to include. (I have horrible handwriting and can type so much faster.)

Printed Pictures & Memorabilia

No doubt, if you are creating a photo book that covers family history or even times from the 1990s and 2000s, you'll have printed pictures to scan.

TIP: Be sure to have a stack of sticky notes. Place one in the location from which you take the picture and one on the back of the photo. Write on both so that you can remember where the picture goes once it has been scanned.

Places to look:

- Photo albums

- Envelopes of photos

- Drawers

- Baby boxes

Go to www.pixologieinc.com/photobooks for a downloadable list of where your photos might be.

Some people are able to find information, photos and documents on ancestry sites as well. I found photos of my ancestor's graves on the Family Search website.[1]

DIGITIZING PICTURES & MEMORABILIA

To put old photos and memorabilia in a photo book, you'll want to scan them. A few options for scanning include:

Flip Pal Mobile Scanner Kodak Alaris Scanner

- Your printer scanner – Be sure to scan as a JPG and at least 300 DPI
- Flip Pal Mobile Scanner – A great tool if you have a small number of photos to scan at a time or need to go to a family member's home to scan the pictures. It uses batteries so you can scan while watching TV.
- High-speed scanner – If you have a large number of photos to scan, consider purchasing or renting a high-speed photo scanner.

Once your photos are scanned, save them to a folder on your computer that you'll be able to find again! Rename the pictures to something meaningful (rather than just numbers). For the purposes of your project, you could name the photos

by the page they will most likely be used. This may help when placing the pictures on the pages.

IMPORTANT NOTES

In our first book, *The Pixologist's Guide to Organizing and Preserving Family Photos*, we teach a very specific system to organize and name digital photos. If you are naming your photos for future reference, create chronological file names as well as you can.

> 1940s Grandma as young girl.jpg
> 1955 Grandma and Grandpa wedding.jpg

A note on backing up your computer: Please be sure you have a back-up for your computer files, especially your pictures and documents folder. It is extremely frustrating to get half-way through your photo book project and have a computer crash. If you have a back-up, this will save a lot of stress. I have actually had this happen to me.

DIGITAL PHOTOS

You'll also want to collect your digital photos in a folder for your photo book on your computer. By collecting everything you need for the book, you'll experience fewer starts and stops in the actual design of the book.

Here's an example of what that might look like once you have gathered all your scanned photos and digital photos.

Have you given thought to how to print your book? If not, the next chapter will be helpful for you.

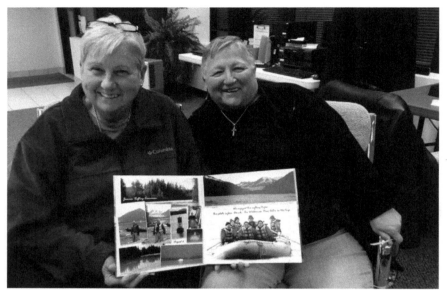

Suzie and Judy, two lifelong best friends who finally had their photos from Alaska put into a photo book.

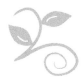

CHAPTER SIX

CHOOSE YOUR PHOTO BOOK PRINTING METHOD

P eople generally make photo books one of two ways— with an online photo book company or with a soft- ware program on a computer. And, just to make life interesting, it is possible to make your photo book on your computer and upload it to a different online photo book company!

And even more crazy, we can now make photo books on our phones. I have found these to be easier for simple, quick one-and-done photo books. Also, smart phone apps for photos come and go. For the purposes of creating meaningful books, I will focus on online companies and photo book software.

As a bonus, once you know how to make a photo book, you can easily create other photo projects. Make posters, calendars, cards, and much more with the many options now available.

ONLINE PHOTO BOOK COMPANIES

The ability to make photo books online has been around since 2004. This is when Shutterfly first offered photo books as a

printing option.[1] Prior to that, people used Shutterfly to print their digital photos. Back in the early 2000s, the digital photography field was exploding. Consumers transitioned from film cameras to the new technology. Snapfish was a part of that boom, but my research shows that they didn't get into the photo book business until after Shutterfly. At the time of this book printing, I have not heard back from Snapfish's corporate office as to when they launched their photo books.

In this day and age, while the choices in photo book printing are numerous, photo book companies come and go. Even Shutterfly has been rumored to be for sale in the past.[2] Snapfish was purchased by Hewlett Packard and then sold back to its original owner, District Photo.[3]

Sometimes, photo book creation websites go offline. Consumers have experienced long waits to have access to their photos and projects. When using an online designing site, please be aware:

- If the company goes out of business or sells the business, your book design may be gone forever.
- If the website is down, you won't have access to your book.
- If you don't have access to the internet, you don't have access to work on your photo book.

For these reasons alone, you will want to start your photo book and create it promptly so as to avoid the situations above. (Or you can create your book on your computer.)

Below I'll cover four online photo book companies: Walgreens, Shutterfly, Snapfish, and Forever. Their websites also offer photo storage, in addition to the creation of photo books. The first three offer full-service photo and project printing websites. Forever is different.

A Bit About Forever.com

Forever.com offers permanent photo storage with a private, secure cloud service to manage, protect, and share family photo collections. In addition, Forever offers computer software for photo management and photo book design. Lastly, it has an online print shop.

We are careful about what companies we recommend to our clients. Photo printing companies go out of business or change hands often. In our research and investigation of Forever, we toured their corporate offices in Pittsburgh and met the founder of the company. As users of Forever's products, we have provided feedback to the company to improve their products and services.

So let's move on to reviewing a few of the places you can order books. There are many more I could have provided. However, I believe the place where you order the book is less important than taking the time to actually create the photo book! If you would like to know about other websites, please see the resources section in the back of this book.[4]

The place where you order the book is less important than taking the time to actually create the photo book!

While I was writing this book and testing the different sites, photo book sales ranged from 40 to 70 percent off! If possible, time your photo book so that you don't have to order it at the last minute. These online photo book providers frequently offer sales.

Each online provider will ask you to create an account. This allows you to save your photos and work if you don't finish in one sitting.

FOREVER PRINT – WWW.FOREVER.COM/PRINT

To start with, I went to Forever to use its online photo book creator. This was, by far, the simplest website to use. If you want to create a book fast without any learning curve, Forever Online Print offers the easiest book builder.

After creating your account, click on Print in the white menu bar. You'll select the size of book, theme and be prompted to upload your photos. Each page allows you to change the page design, which is nice. You simply add photos to the boxes and type your words in the text boxes. You can zoom in on the photos as well.

With the simple interface, there are limitations to what you can do. You cannot move the photo or text boxes around. And you cannot change the font type. I am expecting that as Forever grows its Print services, more features may be added in the future.

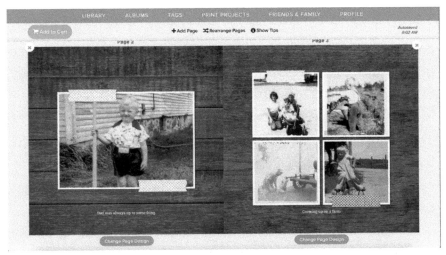

Forever Print screenshot

The 8 x 8-inch, lay-flat book is normally $64.99 for 20 pages. At the time of this writing, it was on sale for 40 percent off, bringing the price to $38.99.

Forever offers an advanced option with its "Forever Artisan" software. I'll be covering that in the next part of this chapter.

WALGREENS – WWW.PHOTO.WALGREENS.COM/

I'll be honest. There is a part of me that turns up my nose at the thought of making a photo book through a pharmacy. However, I recently read a very positive review of Walgreen's Photo Book publishing service. So, I decided to include this as an option for you to design your book. I was pleasantly surprised!

I assumed I'd be ordering a cheap photobook that would be ready in an hour. Walgreens does offer several photo

books that can be ready in a short amount of time, but it also offers many more options available by mail. I chose its "Lay Flat Photo Book" option to test the product.

At first glance, it seems pretty easy to navigate and use. I easily uploaded my photos and began adding them to the book. There are a number of themes to choose from. And, each theme, you can change the layout and theme of the pages to some degree with an option of up to five photos per page.

Overall, I found creating the book to be surprisingly easy for a pharmacy! The prices are extremely reasonable, especially if you take advantage of a sale. When I ordered this 8 x 8-inch lay- flat premium book, it was normally $59.99. My price was $30.

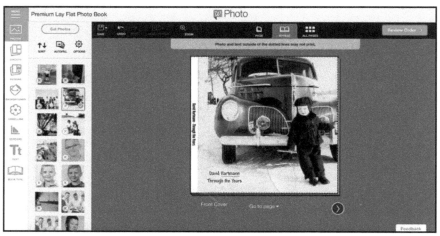

A screenshot of Walgreens.com photo book builder.

SHUTTERFLY

This is the granddaddy of all photo-book-making websites. Shutterfly is a household name and leads the industry in innovation. Chances are you will find a sale for your book as well.

To start off with, somehow, after I uploaded my 78 photos, the page refreshed and my project was gone. I found the website to be somewhat busy with many pop-up windows. The photos were loaded in a row under the book and I found that difficult to navigate at first. Be sure to hit the "Save" button on the top left as soon as you start!

I began in the simple editing mode, which did not allow me to make changes to the layout configuration of photo and text boxes. I could change the layout, but not alter how the photos and text were placed. After ten minutes of experimenting with page layouts, text and more, I became frustrated. As I hovered over photos or other options, the thumbnails would become large and get in the way of viewing my work. The text wouldn't fit. I did not find it a user-friendly experience and I found my blood pressure rising. This is a highly unusual thing to happen to me. . . frustrated by photo book software?

Then, I clicked on the advanced editing feature and calmed down again. This mode gave me more flexibility. I was able to make a couple of pages. I believe with some time and patience, I could get used to Shutterfly's interface. However, for a beginner, this website might be overwhelming.

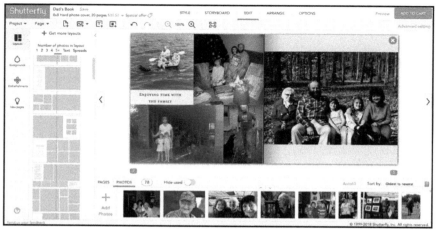

Shutterfly screenshot

The 8 x 8-inch lay-flat printing option was normally $60.98 for 20 pages, but was on sale for 50 percent, off bringing the cost of the book to $30.50.

Shutterfly does seem to have hundreds of themes for its photo books. The company also offers tips, ideas, and a storytelling feature.

Amazingly, it offers to make your photo book for you. If you are happy with the design and order a book, the design cost is just $9.99. You don't even pay this fee until you purchase the book. I requested the design service just to see what they would do.

Once Shutterfly finished my draft book, I received a notification:

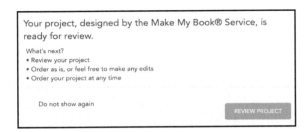

Overall, this could make your job very easy. You may want to add captions, move photos around, etc. Here's a screenshot of how they designed my photo book:

Shutterfly can help design and create your photo book.

SNAPFISH

Many of my clients have photo books with Snapfish's logo on it. So, after turning over my photo book design to the Shutterfly designers, I headed over to Snapfish.com to see what their photo book builder was like.

I was pleasantly surprised to find that Snapfish uses the same photo book interface as Walgreens. I was curious about this arrangement and did some more research. In the past, there were software companies that licensed out their photo book software to other organizations that were willing to purchase it. But, Snapfish and Walgreens seemed too big to need to do that.

My research showed that Snapfish and Walgreens have had a relationship since the early 2000s. Back then, customers were able to pick up their Snapfish orders at Walgreens and save money on shipping.

Still curious, I went to CVS Pharmacy and started a photo book there as well. As it happened, the photo book builder was the same as Snapfish's. Incidentally, Snapfish offers its customers the option of picking photos up at CVS as well. So, I think Snapfish has the market on local pharmacy photo book printing. Just to check, I also went to Walmart's photo book builder and found that their photo book builder was different.

Diving deeper, I visited District Photo's website. Founded in 1949, District Photo is a digital imaging services company in Maryland and the current owner of Snapfish. District Photo

serves companies including Walgreens, Kodak Alaris, Picaboo, CVS, and Costco.[5] Mystery solved.

Back to Snapfish, I began to recreate my dad's photo book using the Snapfish builder. Although the builder had all the same mechanics to create the book using Walgreens' online photo book builder, Snapfish had different designs and fonts to use. I really enjoyed using this builder. I found it easy to enlarge the photos to fill more of the page. I could add text boxes with one click. And, the text box automatically expanded if I needed another line. (With Shutterfly, however, I simply got the message "Not enough room.")

Ordering the book was easy. This 8 x 8-inch version of the lay-flat book normally costs $39.99; however, it also was on sale for only $16 with a 60-percent-off coupon. Keep in mind that shipping and tax are additional. If I would have ordered

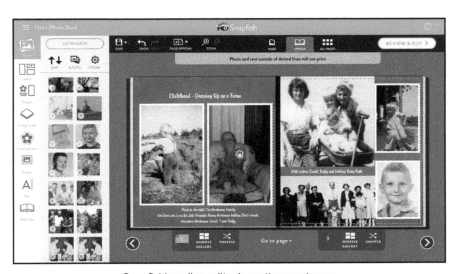

Snapfish's online editor is pretty easy to use.

an 8.5 x 11-inch book, the sale was 75 percent off. (Personally, I really don't like that size.)

Overall, I was pleasantly surprised at how far the photo book industry had come for easy online photo book creation.

Some people enjoy creating custom photo books with complete creative control. Others want to work on their photo books, but might not have internet access. For these people, photo book software offers much more than online photo book builders.

SOFTWARE ON YOUR COMPUTER

In this section, I'll cover both photo-book-specific programs, as well as general publishing programs that can be used. Generally, photo-book-specific programs are easier to use and come with vast amounts of photo book themes to choose from. General publishing software requires more skill and design experience to use. I recommend those for people who have advanced computer design skills.

Forever Artisan Photo Book Software

The first photo book I ever made was in 2007 and included pictures of my daughter's trips to Disney World. At that time, as a Creative Memories consultant, I was selling a digital photo book program called "StoryBook Creator." We were all amazed at being able to get a book professionally printed with our pictures. It was easy and had colorful themes (like a

marbled blue background for the cover!) It was so simple back then!

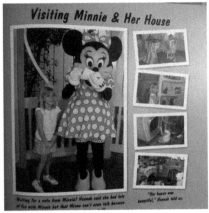

Note the thick white borders around the pictures. This is called the photo matte and back in 2007, we couldn't change the thickness. I don't like thick mattes, because I feel they take away from the photos. Today, my mattes are very thin!

I have been using that same program all these years. There have, however, been some significant changes in company ownership. The software was originally created by a company named Panstoria for Creative Memories consultants like me to sell. Then, Creative Memories went through bankruptcy twice and ended its photo book line of products and services.

Panstoria continued improving StoryBook Creator and even released it under a new name, Artisan. In the meantime, many new art kits were added so you literally have hundreds and hundreds of themes to choose from.

Then, in 2016, Panstoria was purchased by Forever, the company I mentioned previously. Photo books are a natural extension for a company wishing to preserve memories for generations to come. Forever simply added its name to the software and we now call it Forever Artisan.

Photo book companies come and go. However, I believe this has a good ending. Forever's business model includes a special endowment fund to continue its photo storage services for at least the next 100 years.

With Forever Artisan, you create the book and then typically you upload it to Forever.com for printing. However, if you would like to print with another online provider, you have the freedom to do that. You can export the pages as PDFs or JPGs for upload to an alternate photo book provider that allows for full pages to be uploaded.

Forever Artisan software costs $79.95; if you watch its website, you may be able to purchase it on sale.

I have loved using Artisan for many years. You can choose between the "Beginner" and "Advanced" views, depending upon on your skill level. With the beginner level, you can simply drag and drop photos into predesigned pages and type words into the text boxes. If you wish to move photos around, create additional text boxes, and so on, you'll want to use the advanced view.

Themes for Forever must be downloaded from the Forever website. You can find a lot of free content by searching "Free." You can also purchase and download hundreds of predesigned page themes, embellishments and paper. When

Artisan was first created, many scrapbookers started creating their books digitally. They also loved being able to use the "scrapbook" paper over and over again!

A screenshot of some of the Forever content we own at Pixologie.

After choosing the size of your photo book and theme, you'll end up with the view on your computer shown on the next page. You can see that I've already added some of my dad's photos.

Artisan is my go-to program when I design a book that needs a theme. I have found that saving pages can take a while. When you change pages, the program saves the one you were working on. Currently, Forever does not offer Artisan for Mac.

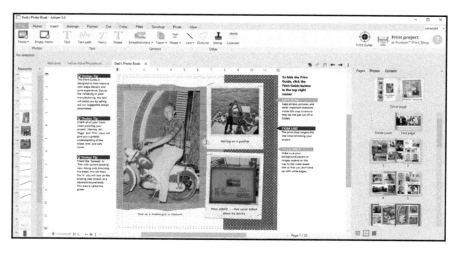

The narrow left-side panel shows all of your individual page elements. You can select individual items for layering, etc. Center: your current photo book layout displayed. Note the tabs—you can have more than one photo book open. There are helpful design tips on the screen. The right-side panel shows the other pages in the book, as well as tabs for Content and Pictures. The top row of tabs: You have many design options to work with your photos in these tabs.

MyMemories Suite

Quite a few years back, Ann and I met the software developers from MyMemories Suite. At the time, we tried their software and ordered a few books. However, we both returned to our favorite program, Artisan, for photo book making.

I spent some time using the latest version, MyMemories Suite 9.0, and found the software to be easy to use. In addition, MyMemories Suite earned a Gold Award from TopTen Reviews. They almost earned a 10.0 on their rating scale.[6] It has also received good reviews elsewhere. I also observed that the program is very quick to save when going to the next page.

Here is a screenshot of the program as I started making my dad's book. On the left-hand panel, you have your gallery and content. The editing tools are on the right side in the Control Panel. MyMemories Suite also has a lot of additional papers, embellishments, and themes you can purchase.

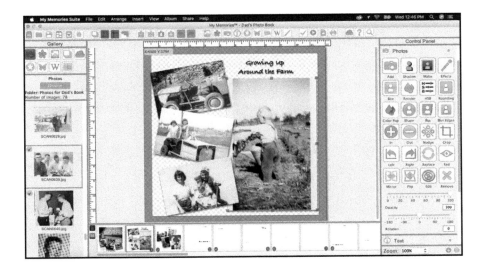

The appearance of the program does feel somewhat dated to me. Overall, though, I was extremely impressed with the functionality and speed of the program. It sells for $39.95 and can be installed on PC or Mac.

PHOTOS FOR MAC

Prior to Apple's latest Mac operating system release of Mojave, people could make photo books right in the Photos App on their computer. Since Mojave, the latest Mac operating system, launched, Apple still allows people to create books in the Photos App. You must download an extension (Motif, Mimeo Photos, Shutterfly, ifolor, WhiteWall, Mpix, Fujifilm, and Wix) from the App Store.[7] Ugh! Why do these companies have to change things that work?

Well, okay, I obviously need to give this new twist a try. On my Mac, I downloaded Mimeo from the App Store and it seamlessly integrated into Photos, which was nice. I did have to restart the project a couple of times.

Once I learned how to change layout options, I found the book very easy to make. On the right-hand side of the screen, you can see a column with photo, text, layout, and back-grounds. Just click on anyone of options to the corresponding work.

Mimeo did not offer many themes. That isn't a problem for me since I enjoy photo books made primarily with photos.

While you are working in your Photos app on your Mac, you do need to drag your photos to the project before

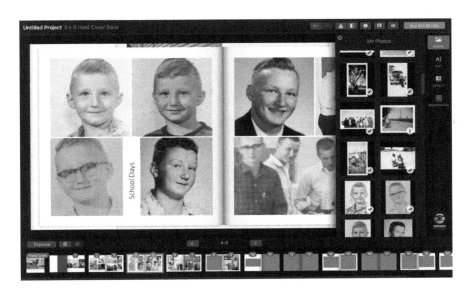

entering the project. You can't simply add a photo from your Photos library. This is also inconvenient if you have your photos and documents ready to go in a digital folder outside the Photos app.

In the screenshot below, you can see that "My Photos" has no option to bring in photos to the project. You'll need to go

back to your photos, select the ones you want, and drag them to your project in the left-hand navigation panel.

The cost of this 8 x 8-inch hardcover book with 20 pages is $24.99. I did not see a lay-flat option, which is a problem if you like to have a higher-quality book printed.

Perhaps other Photos extension apps might make the software easier to use with more printing options available. Since very few of my clients have used their Mac Photos to create a book, I didn't spend any more time researching the other options.

MICROSOFT PUBLISHER

Microsoft offers Publisher as its desktop publishing program. It was not designed for photo book creation, and I had never known anyone to use Publisher for a photo book. However, my publisher, Kira Henschel, showed me a photo book she made with the program. It looked fantastic!

We have used Publisher for clients who have a heavy amount of text with their photos. I did find a YouTube video online of a gentleman making a photo book to catalog his cars.

Opposite is a screenshot from a book I created to show you a screenshot of using Publisher. If you are comfortable with other Microsoft products, this will look familiar.

If you are intent on using a desktop publishing program, but are a beginner, Microsoft Publisher could be an option for you. It is much easier to navigate and use than Adobe

inDesign. You'll need to export your pages and upload to your photo book print provider.

ADOBE LIGHTROOM AND ADOBE INDESIGN

Back in the late 1980s and 1990s, I witnessed the field of desktop publishing come to the forefront. I was the editor in chief of our high school's PRINTED newsletter. I watched the disappearance of blue pencils, layout grids, and rubber cement. We began using Aldus Pagemaker to digitally layout our newspapers. I truly marvel at the technological revolution my generation has seen.

Below are some issues of the 1987 Oak Creek Knights Newsletter.

Our team back in the day.

Pictured left to right are the editors of the 1989-90 school year: Michael Takach, Justin Knapp, Chris Wacholz, Molly Hartmann, Holly Goelz, and Jeff Kaluzny. Not pictured are Jenni Cutaforth, Theresa Dickison, Rosie Hartmann, and Kevin Wozniak.

In college, I started my first business "Clipper Publishing" using Aldus Pagemaker. I created newsletters, flyers, posters, and more for local businesses. When my dad, an avid line dancer, wanted to publish a newsletter for Southeastern Wisconsin line dancers, I was all in. The next page shows a photo of some of the newsletters we produced and sold over the course of a few years.

Today, photo book design is a futurized version of what we were doing back when I was a teenager. While *The Vine* isn't a photo book, it helped provide me with the background

to understand the power of computing back when it was so new. We don't use the words "desktop publishing" anymore and instead use "graphic design." Aldus PageMaker was acquired by Adobe in 1994.

Adobe offers a full, complex suite of software to people who work with graphic design, photos, movies, and much more. In addition to their photo editing product, Adobe Photoshop, Adobe Lightroom, and Adobe inDesign can be used to create photo books. (inDesign was developed from Aldus Pagemaker.)

I've met people who use Adobe Lightroom and Adobe inDesign for photo book making. In general, they have advanced computer skills and/or they are professional graphic designers.

On the following page is a screenshot from Adobe Lightroom. The interface is much simpler and really has no themes. You can adjust the number of photos that appear on a page. If you are looking for a simple solution to create books with just pictures, this could be an option. There is a text editing feature to add captions and narrative. When I opened the

book option, Lightroom auto-placed the photos for me as single-image pages.

Look at the screenshot from Adobe inDesign. Every piece of the photo book is hand-placed and the layouts manually put together. You can see the controls and options available

A screenshot from Adobe inDesign.

for editing the page in the icons that take some time to learn and use.

Because Adobe inDesign is a powerful program, layout time is very fast. With other photo book software, saving pages can be time consuming. Other than that, I would definitely recommend other options for creating photo books.

Also, if your photo book has extensive narrative that runs from page to page, you may want to consider Adobe inDesign.

Adobe Lightroom and Adobe inDesign are available through Adobe's Creative Cloud service, which is a subscription-based software. The full Adobe Creative Cloud Suite is currently $52.99 per month, but you can just subscribe to the Adobe inDesign software for $20.99 per month.

Once your design is finished, you export the pages and upload them to your chosen print provider.

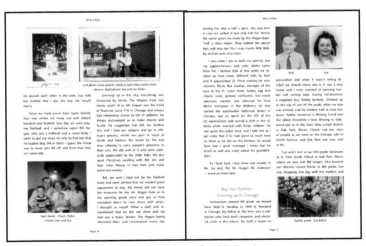

We used inDesign for this book,
which was more of a memoir than a photo book.

Hybrid Option
Using Software to Upload Photo Book to Online Provider

Some people appreciate the option of first making their photo book on their computer. Then they upload it to their preferred photo-book-printing provider. We order from quite a few photo book printers depending upon the quality of book we need, the sizes offered, and the pricing available.

Both Forever Artisan and MyMemories Suite will export your photo book to JPG or PDF. Microsoft Publisher, Adobe Lightroom, and Adobe inDesign allow you to do the same. Here are some sites to which you can upload your photo book pages for printing.

- Shutterfly (choose the "digiscrap" theme)

- MPix

- Mixbook

- AdoramaPix

- Blurb

- Artifact Uprising

This chapter was intended to give you a quick overview of the different ways you can make a photo book. If the photo book design process seems overwhelming, with time and repetition, you can get very good at making photo books.

It doesn't really matter what way you make your photo book. It is much more important to pick a solution and start using it. Practice and repetition really do help make the photo book creation go much easier. The first few pages might take a while, but after completing your first book, you'll feel much more comfortable creating photo books!

CHAPTER SEVEN
CREATE YOUR PHOTO BOOK

We've covered a lot in this book already. Hopefully, you can now get started on creating your photo book! Let's review the steps:

- You've decided what this photo book will be about
- You've created an outline
- You've scanned all photos and memorabilia and copied them to a folder on your computer. You may have typed the narratives and captions you want already; you've added the digital photos necessary as well
- You've chosen how you will make your photo book

With good planning and thoughtful execution, your photo book project should be enjoyable. By putting the prep time in, the actual creation of the photo book should be a smooth process.

I'll demonstrate how to create one photo book using the simplest option: Forever Online Print. Please keep in mind that by the time you read this book, it is possible these screenshots and techniques could be different. I am hoping you'll get more an idea of the thought process behind the

photo book creation. This guide does not explain in detail how to physically design photo books with other programs.

> If you are interested in using Forever for your photo book project, please consider adding Pixologie as your ambassador. We do receive a commission for helping people find and use Forever products and services. :) We thank you!

As with all online providers, you will need to create an account with Forever to get started.

Here's the outline for my dad's book, which we already looked at above:

- Page 1: Title Page – David Hartmann Through the Years
- Pages 2-3: Childhood Photos with siblings
- Pages 4-5: Teens and high school
- Pages 6-7: Serving in the Military
- Pages 8-9: Meeting Mom
- Pages 10-11: Wedding
- Pages 12-13: Having Kids
- Pages 14-15: Outdoorsman
- Pages 16-17: BBQ Competitions & Fun Times
- Pages 18-19: Fun Times & Photography
- Pages 20-21: Love for my mom, life and last photo*

*Interestingly, Forever's standard book gives one additional page. Normally, photo books come with 20 pages.

First, I went to www.forever.com and clicked on Print Projects . . . and scrolled down to Photo Books.

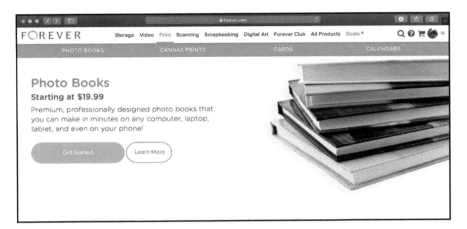

Then I clicked on Get Started and was able to scroll through the themes.

(If you haven't created a Forever Account, the site will prompt you to do so now. Once you are logged in, you will be directed to the Photo Book project.)

I chose Simple Black Plus, clicked "Get Started" and landed here.

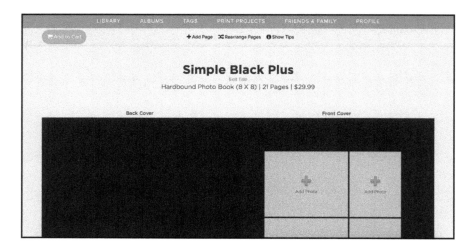

Next, I clicked "Add Photo" in one of the boxes and was directed to this next screen. You can see a couple of items in the blue bar.

You can add photos from either your Forever library or Forever albums if you have already uploaded pictures. If you need, upload the photos you want in your book at this time. Here's a screenshot of when I uploaded photos to an album I named "Temp Dad's Photos."

Then, I found the one I wanted to go in the box I selected from the photo book print designer screen.

Once I chose the photo, Forever filled it into the photo book. I could enlarge the photo (using the "zoom" option) and move it around in its photo placeholding box.

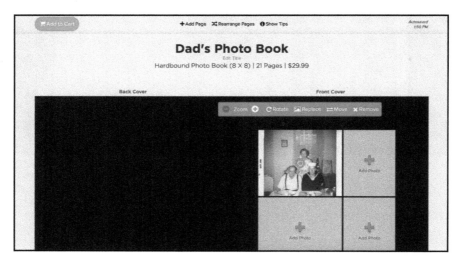

Now that I had that photo placed, I added the rest of the photos and a title on the page.

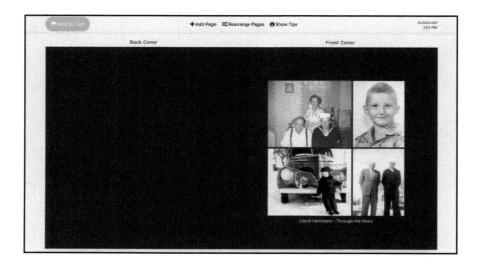

The Forever page simply scrolls down to the next page. See the blue "Change Page Design" button? This page originally had nine photo spots on it. I didn't want that many and changed it to a three-photo page. There are many page options to choose from in the theme.

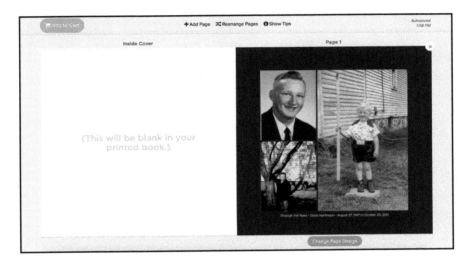

It is very quick and easy to put the rest of your photos in, especially when you've already planned out what will go on each page.

On the next page are pages 2 and 3, which took me about three minutes to complete!

On pages 4 and 5, I outlined that these pages would cover my dad's teen and high school years. I did find a photo of him on a motorcycle from when he served in Vietnam and thought it would be neat to include the photo of his father on a motorcycle from back in 1920.

Forever Online doesn't allow for much text, so I couldn't include much more about the motorcycle photos for now.

Here are pages 4 and 5:

Your outline can be a work in progress. I have certainly made changes to the flow my photo books as I start putting them together. Sometimes, things that weren't obvious in the planning process make a story better!

On pages 6 and 7, I have photos from my dad's military service. But then, I realized I had the pages reversed.

I was able to click on the "Rearrange Pages" button screenshot) and this easy-to-use screen came up. You can see pages 6 and 7 below.

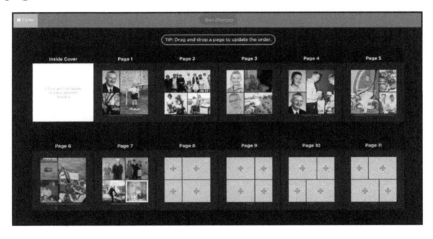

I switched the pages and was able to move on to 8 and 9. Those pages are shown on the next page.

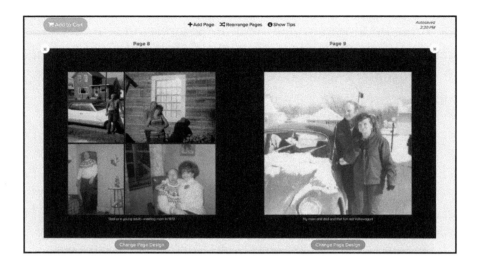

Then pages 10 and 11 for their wedding.

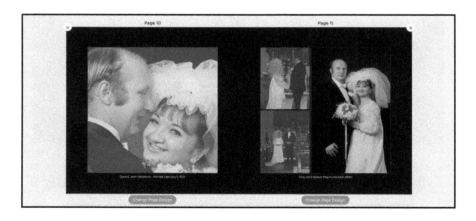

Next are pages 12 and 13—starting a family!

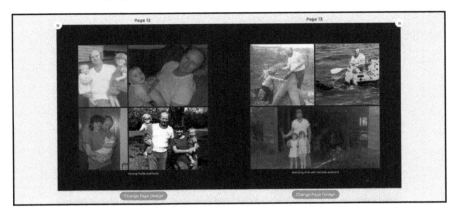

My dad always had a variety of hobbies and loved being outdoors. It's fun to see a photo page of all the different things he did. Here are pages 14 and 15:

On page 16 below, you can see my dad enjoyed the challenge of BBQ competitions with his big smoker. Page 17 shows some fun times we had together.

On page 18, more fun times. (See the upper left photo—he's line dancing at my wedding! And page 19 shows my dad on a photoshoot at a farm, selling his photography, and with me at Pixologie's Grand Opening.

On pages 20 and 21, I ended with his love for my mother and a photo of him and his camera.

KEEP A COPY OF YOUR PHOTO BOOK

Regardless of what program you are using to create your book, be sure to store a digital copy of it in two locations, one in the house and one outside of the house. Some online providers also allow you to download a PDF version of your photo book.

If you are using a software program, you should also save the working file in two locations. If something should happen and you need to reprint the book or make a change to it, you will be grateful to be able to go back and edit or order more copies.

Wrapping Up

Well, now we've walked through creating a photo book using a simple online provider. I hope this chapter provides enough information if you need an easy way to make your first book.

If you wish to create a book with a little more creative design control (like picking your own size of text, font, etc.), I highly recommend Snapfish. I really enjoyed their interface and found it easy to use as well.

Once your photo book is finished, you can easily order additional copies. In some cases, you can also order different sizes of your photo book.

Photo books can take up to three weeks or more for printing and shipping. Be sure to plan ahead if you need to have the book by a certain deadline or special date.

MORE PHOTO BOOK STORIES

As I write this, I wonder if I could possibly be providing too many examples of photo books. I hope not, and I also hope that I still have your attention. This chapter provides a few more examples to help demonstrate the power of photo books. It also will help you to know what to expect when you create one for the first time.

DOING SOMETHING SPECIAL FOR HER DAD'S BEST FRIEND

I first met Dusti long before I was a photo organizer. She and I were part of the same team selling scrapbooks and photo-book making supplies. Unfortunately, when that company went out of business, Dusti was unable to order photo books the way she had in the past. She called me to see if I could help. Her software (remember StoryBook Creator?) still worked, but she had no way to order the photo book she wanted.

Dusti's photo book was a major undertaking. She was helping her dad's best friend Frank tell his story of serving in World War II. Frank and her dad had seen major action, lost friends, and experienced great hardships in the war. Frank had written these stories down and he had photos as well.

Dusti painstakingly created the photo book for him. In the end, the book was nearly 75 pages!

Here are a few pages from his book:

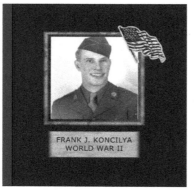
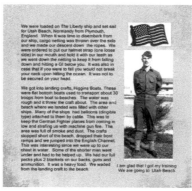

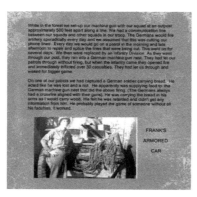

Frank ordered 24 copies of the book and gave them out to his family. A few months later, he needed another supply. We ended up producing the books as soft covers to save him money because he was going through the books so fast. In all, I think he shared over 60 books with friends, family, and others who wanted his book.

Recently, I provided a quick talk at an apartment complex for people interested in scanning their photos. While there, I had Frank's book on display. A gentleman asked to look through it and he spent a good hour reading and rereading the Frank's stories of bravery and valor. He actually was moved to tears and told me, "I served in the Navy also and retired. I've heard about these stories of war but I have never met anyone who lived through it." He was so grateful for the opportunity to read Frank's stories and see the actual photos from those times.

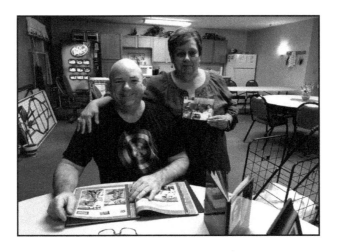

Frank's book was amazing also because it was a first-hand account of what a soldier actually experienced in the war. There is little chance left now to record veteran's stories from World War II.

We are living in the last generation to remember when words were written and photos were printed. If we don't start recording some of these stories, they will be gone forever. I

am so grateful that Frank spent the time writing the story and Dusti took the time to create the photo book to bring it all together.

CREATING A MASTERPIECE FOR MY SISTER

As a photo organizer, I am sometimes nervous about assisting professional photographers. Clearly, they are experts in their field and know their F-settings and advanced photo editing techniques. And, many feel an affinity for the work we do in preserving photos. I always want to do justice to what they have caught with their cameras.

My sister, Rosie, is one of those amazing photographers who capture the essence of life by framing the photo just so. She spent six years in a row, taking a photo a day, and sharing it with the world. She had the tenacity and grit to actually travel to Thailand by herself. Then, she went to Vietnam, the lesser traveled location, also by herself!

When she returned from Thailand, she had taken over 2,000 photos. She fully intended to make a photo book but after eighteen months, she just couldn't start. Rosie told me, "Just do it. I can't pick the best photos."

Well, I was anxious about this project because Rosie has such high standards for her photography, but I dug in to figure it out. My first step was to look at her digital photos by day. I grouped each day's photos in a folder. Then, I chose the absolutely best, most stunning photos taken from each day.

The outline for her book was very simple. Her photo book did not need any words, for her pictures would be strong enough to carry the story.

- Page 1: Title page, best photo
- Pages 2–5: First Day's photos
- Pages 6–9: Second Day's photos
- Pages 10–13: Third Day's photos
- Pages 14–17: Fourth Day's photos
- Pages 18–21: Fifth Day's photos
- Pages 22–25: Sixth Day's photos
- Pages 26–29: Seventh Day's photos
- Page 30: Wrap-up page

Well, apparently I didn't count the photos for each day very well. Rosie's book ended up being a beautiful 12 x 12-inch, lay-flat premium hardcover book with 70 pages!

Here are some of the pages from her book:

When Rosie saw her book for the first time, the stories just flowed out of her. Flowers, food, expensive Coca Cola, panda bears, buddhas, and so much more. She was thrilled and couldn't wait to show everyone the final product. Most people had stopped asking when they'd get to see all of her Thailand pictures.

I love the photos of the chickens and roosters. You can see Rosie's photographic process as she focuses in on the best shot of all. I love the rooster on the fence with the beautifully blended background!

If you'd like to see the rest of Rosie's beautiful photo book, go to www.pixologieinc.com/photobooks.

TRAVELING AROUND THE WORLD

Remember my client Gen? She was blessed to travel to every continent and over 50 countries in her lifetime. At the age of 79, however, her travel photos were mixed in with decades of family photos, boxes, memorabilia, and more. Often, people go on wonderful vacations and then don't look at the photos taken. After helping Gen organize over 10,000 photos, we separated out her travel photos and began planning her Travel Book.

We didn't just create one book for each trip. Rather we took the best moments and scenes from ALL of her trips and created one photo book. The front and back covers of her 100-page book are shown on the next page.

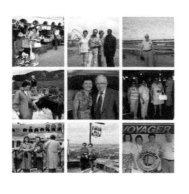

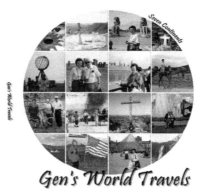

Gen's World Travels

Gen traveled with her family and the memories were so wonderful. She told me, "You've restored my life" when we done with her photo organizing. However, that job was not complete until her memories were reprinted in photo books.

Here are a few pages from her book:

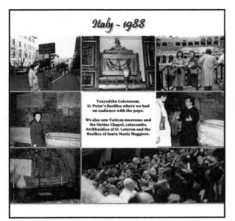

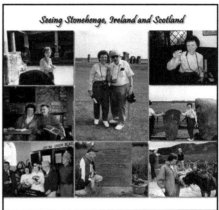

Now, if Gen and I could pull this book together with all its narrative and pages, I hope you are inspired to revisit your best vacation memories!

HARTMANN HISTORY BOOK

Do you have a family reunion every year or two? I previously mentioned that we do. Each time, it is held in a different part of Wisconsin, depending upon which cousin is hosting it. Back in 2009, my Aunt Carol and I made a photo book to share some of the Hartmann history. We also wanted to have fun reminiscing with the family about past family reunions.

Here's the outline for the book:

- Page 1: Title page, great photo of my grandparents
- Pages 2–3: Grandfather's history / Grandmother's history
- Pages 4–5: The Hartmann Siblings / pictures of them through the years
- Pages 6–7: Aunt #1's pages / Family Listing / Photos

- Pages 8–9: Aunt #2's pages / Family Listing / Photos

- Pages 10–11: Aunt #3's pages / Family Listing / Photos

- Pages 12–13: My Dad's Pages / Family Listing / Photos

- Pages 14–15: Aunt #4's pages / Family Listing / Photos (My dad had four sisters!!!)

- Pages 16–17: Reunion Photos

- Pages 18–19: More Reunion Photos / Fun White Elephant Auction Photos

- Page 20: Run Down of the Family by Generations

I love this layout and how it shows all of our family through the years. Here are a few pages from the book:

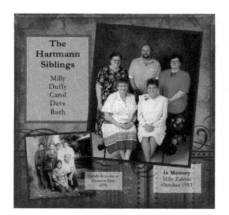

Go to **www.pixologieinc.com/photobooks** to see the full book.

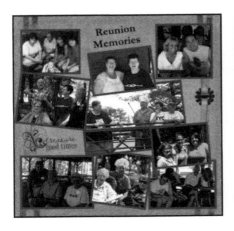
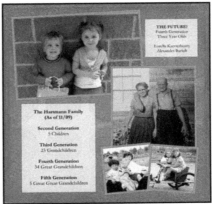

What a Trip!

I've had this lucky life with odd experiences I never have thought would happen to me. Around 2011, my friend Christy and I had this bright idea to take our daughters on the road trip of a lifetime. We both enjoyed traveling in the car. We planned a 3,300-mile road trip that we completed in seven days! We were big scrapbookers back then and I was already planning what I would need to document this journey.

June arrived, school let out, and we girls were on our way. We traveled through 22 states, two countries, and two provinces! We had to go through the border crossing four times and have some great stories about the border patrol. (Please note: Don't ever show a border patrol agent your itinerary with a major city circled in red. It took us a bit to get out of that situation!)

Our girls were treated to almost every landmark along the Northeast coast, including Salem, New York City, Washington DC, and so much more. We hit Gettysburg and Niagara Falls. We lost the car keys in Sandusky and visited my sister-in-law in New Hampshire. We had a bathroom emergency at the Statue of Liberty. Who knew it would take four hours to get from downtown Manhattan to the statue? And, that there would be NO acceptable bathrooms along the way. The traffic jam took three and a half hours alone—there is no parking when in rush hour!

My scrapbook was an epic 62 pages long. My outline was extensive, and I didn't quite keep to the 60 pages I had planned, but I came close. It included photos, memorabilia, and our ill-fated map with Philadelphia circled in red! It took me about six months to complete. The book is about three inches thick and weighs ten pounds.

A few years ago, I scanned the pages and made a smaller version of the album so I could enjoy it and share it more easily.

Here are a few pages from the book:

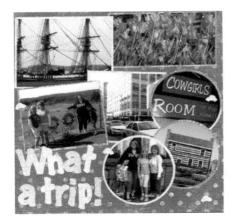

Christy and I will never forget how wonderful that trip was! And, we would never have remembered all the stories I wrote in the scrapbook. Now with the pages digitized, we'll have these memories vividly for the rest of our lives. And so will our daughters!

Here's a photo of the original scrapbook and the smaller one I made digitally.

WEDDING BOOKS

With the advent of digital photography, more and more couples simply receive their wedding pictures on a DVD or flash drive. We meet a lot of people who have never done anything with the photos from one of the most important events in life.

Enter Erica, who actually only had the negatives from her wedding back in 2001. We had to scan them first before creating the photo book.

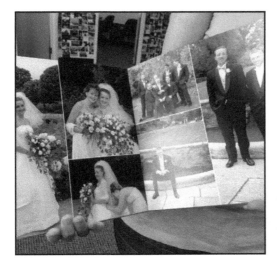

The outline for a wedding book is pretty standard.

- Page 1: Favorite bride and groom photo (Optional: a photo of the church)
- Pages 2-3: Bride getting ready with bridesmaids/Groom getting ready with groomsmen
- Pages 4-5: Procession into church/father of bride hands bride to groom (maybe photo of musician)
- Pages 6-7: Service (Readings/Vows/Rings)
- Pages 8-9: Bride and Groom Kiss/Recession
- Pages 10-11: Bridal Party Photo Shoot
- Pages 12-13: Entrance to Hall/Cake Photos
- Pages 14-15: Toast, Invocation/Dinner
- Pages 16-17: Important Dance Photos Father of the Bride/Mother of the Groom/Bridal Party
- Pages 18-19: Dancing Photos/Garter & Bouquet Toss
- Pages 20: Final farewell photo of bride and groom leaving

Obviously, you may want to add many more pages to include other parts of the wedding.

- Group shots of each table
- Family groups
- Any other artistic or creative photography done at the wedding.

IN CONCLUSION

Wow, we have covered so much about photo books. Are you overwhelmed, or do you think you have a handle on the subject? Over the past ten years, I have worked with hundreds of clients. My observation is this: ***If you go in with a specific idea in mind, you are far more likely to complete your photo book.***

I have provided dozens of topics, ideas, and thoughts on how you can preserve the stories in your family. Pick the one that means the most to you and get started. The sooner you start making progress, the more enthusiastic you'll be to complete the book. And then, you'll want to get going on the next one. You'll delight your family members with the memories and you'll be helping future generations know about your history.

Here's another way to think about your photos and photo books. Life just seems plain busier today than when I grew up back in the 1970s and '80s. In fact, I can barely remember what I did last week or even over the past summer. When I look at my family photo books, I am so happy to see all that my family has done together. I am shocked at how little I recall without having the photo books, and I'm only 46. What will I remember when I am 60, 70 and 80?

How much will you remember if you don't look at your photos and photo books? If you are dealing with thousands of photos living on your smartphone, your photos aren't telling stories and reminding you of the good times in life. Worst case scenario: you lose your phone and the pictures aren't backed up. Now the memories may be gone forever without the visual reminder of what your family did together.

> *The memories we make with our family are everything.*
> —Candace Cameron Bure

My mother-in-law looks at her books every week. She enjoys the memories and showing the books to her visitors. I have shared my method so that you can create books that you will enjoy and that your family will treasure for years to come.

I wish you all the best as you make wonderful photo books. I'd love to hear from you about the photo books you complete. Feel free to contact me in several ways:

Linkedin: linkedin.com/in/molliebartelt
Facebook: facebook.com/pixologie
Twitter: twitter.com/pixologie
Email: mollieb@pixologieinc.com

With warmest regards,
Mollie Bartelt

RESOURCES & NOTES

CHAPTER ONE

(1) Pages were scrapbooked, but I never finished any other pages for that year's scrapbook. I scanned these and saved them digitally.

(2) Family Narratives Lab - https://scholarblogs.emory.edu/familynarrativeslab/people/

(3) 20 Questions - https://www.psychologytoday.com/us/blog/the-stories-our-lives/201611/the-do-you-know-20-questions-about-family-stories

(4) https://firstthings.org/teaching-family-history

CHAPTER FOUR

(1) http://spiritauthors.com/news/top-10-reasons-plus-1-why-an-outline-is-important-when-writing-a-book/

CHAPTER FIVE

(1) www.familysearch.com. A free website to access. I found photographs of my ancestors graves through a link to "Find a Grave" website.

CHAPTER SIX

(1) https://www.shutterflyinc.com/history/

(2) https://www.cnbc.com/2014/07/03/why-shutterfly-is-probably-going-private-they-missed-mobile.html

(3) https://www.bizjournals.com/washington/news/2015/04/21/district-photo-brings-snapfish-back-into-its-fold.html - District Photo http://www.districtphoto.com/milestones/ - bought Snapfish in 2001

(4) Photo book review sites:
https://www.toptenreviews.com/services/multimedia/best-photo-books/
http://www.photobookgirl.com/reviews/
https://www.tomsguide.com/us/best-photo-books,review-2651.html

(5) http://www.districtphoto.com/clients/

(6) https://www.toptenreviews.com/home/crafts-sewing/best-digital-scrapbooking-software/mymemories-suite-review/

(7) https://www.apple.com/macos/photos/

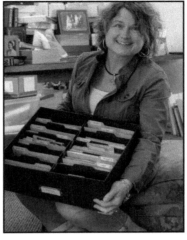

ABOUT THE AUTHOR

Mollie Bartelt—photo organizer, Pixologist, mission–driven entrepreneur—is on a mission to save people's stories and ensure future generations have a meaningful photographic family history.

Mollie's career started in the nonprofit, healthcare and assisted living fields, where she ran adult day centers and other community programs to help older adults remain living in the community. Even back then, she saw the value of family photographs and photo albums as a comfort and memory tool for her clients.

Along the way, Mollie joined a direct sales business in the memory-saving field and sold scrapbooks, photo albums, and

digital photobook software. She loved creating books for her children to look through and see all the family had done together.

In fact, one summer, while her husband was unemployed, Mollie remembers Labor Day coming and school starting. She felt terrible because, with limited finances, the family hadn't been able to do much. However, over that weekend, she caught up the family album with summer pictures and realized how much the family had done . . . from campfires in the backyard, beach trips, nature walks and so much more. Mollie often says, "If I didn't have photos of what we did, I wouldn't remember very much at all."

It was during this time of selling memory-saving supplies, that Mollie met her future business partner, Ann Matuszak. Both Ann and Mollie, along with their other friends in the business were very disappointed when their direct sales company went into bankruptcy for the second time in 2013. It appeared to be closing their doors permanently.

Ann had an idea of starting a photo organizing business and Mollie was hooked on the idea. They both knew their customers often purchased the albums and software, but often never actually put the albums together. In fact, a photo organizing business could really give people hands on help to saving their memories. Pixologie was born three weeks later on July 25, 2013.

Mollie quit her successful healthcare career in 2014 when Pixologie opened its first location. She work with clients individually, teaches photo organization classes and has

helped organize nearly one million photos since starting. She wrote "A Pixologist's Guide to Saving Family Photos," so that more people could learn how to preserve their family memories.

Lastly, Mollie has worked with the Wisconsin Senior Olympics for the past six years helping the nonprofit grow the games. Over 1200 athletes, 50 and older, compete in 20+ sporting events. It is not your grandma's senior center program! Mollie has helped the organization preserve over 3300 photos from the past two decades. Just imagine the stories and inspiration those photos will provide the athletes children and grandchildren! What is important in life? All the technological advances we've achieved that seem to keep us inside and isolated more? Or getting outside to compete, play, and enjoy life?

Mollie is married to Paul and has two children, Hannah and Alexander. She sings in her church choir and her goal is to help make the world a better place by helping people enjoy and share their memories and family histories.